DRAWING & PAINTING

FANTASY LANDSCAPES

& CITYSCAPES

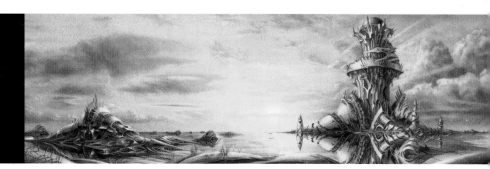

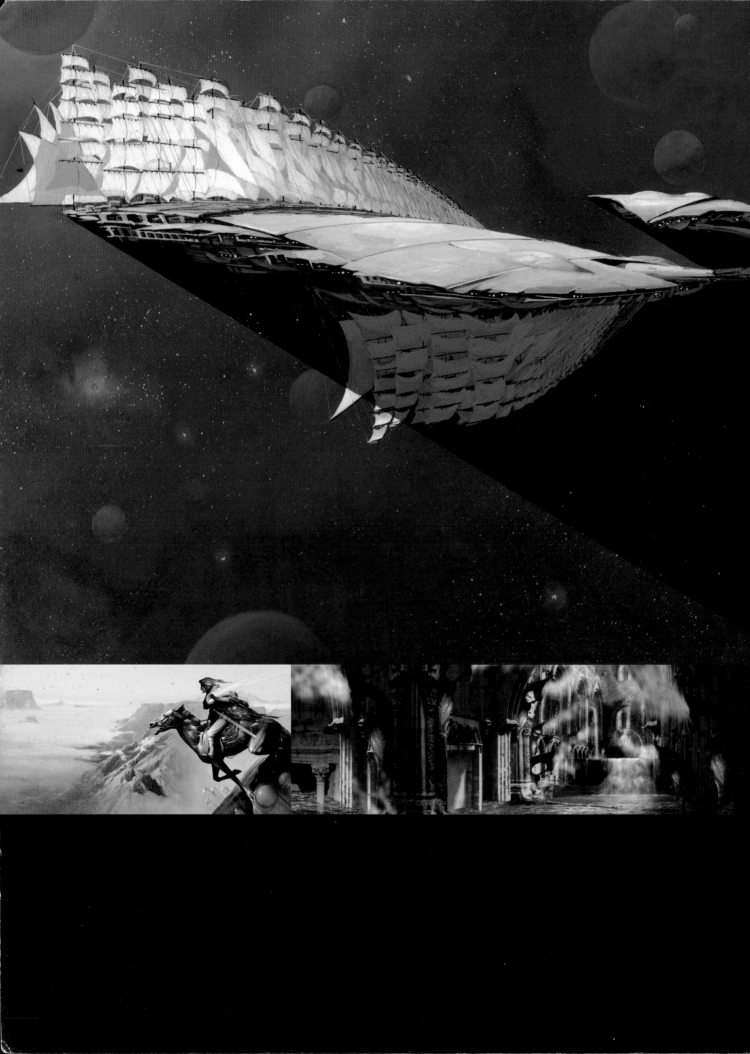

DRAWING & PAINTING FANTASY LANDSCAPES & CITYSCAPES

Create your own mythical cities, planets, and lost worlds

ROB ALEXANDER
With a contribution from Martin McKenna

BARRON'S

A QUARTO BOOK
First edition for North America published in 2006
by Barron's Educational Series, Inc.

All inquiries should be addressed to:
Barron's Educational Series, Inc.
250 Wireless Boulevard
Hauppauge, NY 11788
http://www.barronseduc.com

ISBN-13: 978-0-7641-3260-5
ISBN-10: 0-7641-3260-1
Library of Congress Control Number: 2005920614

QUAR.LCS

Conceived, designed, and produced by
Quarto Publishing Plc
The Old Brewery
6 Blundell Street
London N7 9BH

project editor: *Lindsay Kaubi*
art editor and designer: *Elizabeth Healey*
copy editor: *Claire Waite Brown*
assistant art director: *Penny Cobb*
picture researcher: *Claudia Tate*
proofreader: *Sue Viccars*
indexer: *Diana LeCore*

art director: *Moira Clinch*
publisher: *Paul Carslake*

Manufactured by Provision PTE Ltd, Singapore
Printed by Star Standard Industries PTE Ltd

Printed in Singapore

987654321

CONTENTS

INTRODUCTION

This book is intended for the serious artist or art student. It will teach you what you need to know in order to draw and paint your own images well and with confidence, as well as give you a good understanding of the hows and whys of picture-making. The focus is on fantasy landscapes, but the information applies equally well to any form or subject of representational painting.

Once you've read through the book and become both familiar and comfortable with the information presented, you will have a firm grasp of the fundamentals of drawing and painting, and a good introduction to materials. You will also have had the chance to get behind the eyes of several of today's best artists, to study not only what choices they've made but also why those choices were made and why they work.

Remember, also, that once you have learned the rules, you will have a much better understanding of when and how to break them. Rules are meant to be broken, but first you must understand them.

This book is organized into four chapters: Basics of Art, Elements of Landscape, Creating Fantasy Realms, and the Gallery, each building upon the information that precedes it. A great painting doesn't just happen; it is crafted. It comes about based on the choices and experiences of the artist. The artist decides that he or she will create something wonderful, then brings all his or her skill and knowledge to bear in order to craft the painting and make it a masterpiece.

This book will show you how to do that and allow you to create beautiful images of your own.

CHAPTER 1

BASICS OF ART

Basics of Art first discusses that most personal of choices: which medium to paint with. This section will familiarize you with many of the most common mediums in use, show you what the strengths of each are, and allow you to find the best fit for your particular style. Basics of Art then covers all the fundamentals of art, from getting inspiration to composition and color theory, perspective, values, and achieving depth and mood, including a study of the use of different seasons, time of day, and weather to allow you to create the image you want effectively and with confidence.

PENCILS AND INK

Graded pencils can be used to make a variety of different marks and a range of values.

Pencils and ink are the most common and familiar of all the artist's tools. Portable, easy to use, and versatile, they are a staple in almost every artist's repertoire. However, their familiarity and the ease with which they may be picked up and used often leads us to forget an underlying truth to drawing with lines and marks. Namely, that of all the aspects of a scene that an artist tries to capture on the page or canvas— value, texture, form, color, and so on—line is the only one that does not exist in nature.

Dip pens are great tools for making expressive lines.

What we think of as a line, what we draw as a line, is the apparent edge of an object, the internal structure of the object, or the meeting point of two shapes or planes. You may draw a line where a tree branch and the sky seem to meet, but if you change your position and walk behind the tree, you will find that that line does not exist and that there is no edge to the tree branch.

LINE DRAWING
It is possible to create an accurate representation of a scene simply by mimicking what you see before you, by mixing dabs of color in the correct value and hue and applying them accurately to the canvas. Lines, however, are a creation of the artist: an attempt to create something that has meaning only because the choices of the artist give it meaning.

A line may be soft and suggestive or hard and harsh. It can be crisp and clean or broken, dark or light, thick or thin, large or small. The artist needs to be able to use all of these variations and more in every portion of every drawing he or she does in order to convey the illusion of reality to the viewer.

Line drawings are concerned primarily with edges and how these are created or affected by light. When you look at the edges of something you begin to get an understanding of its nature and how it is being affected by the light. You will notice that illuminated planes have a crisp edge, while those in the shadows have a much softer, less defined edge. Hard planes, such as those of a building, have a strong delineation from their environment, while the rounded tree trunk will be less distinct.

Accurate drawing requires both a very intimate knowledge of your subject, and the ability to communicate that knowledge to the viewer. As an artist you need to think about whether the object curves toward you or away from you, and how you would draw that. Is the material you are drawing soft or hard, thin or thick, flexible or rigid? Or a combination of all these aspects?

As you pay more attention to the edges and linear qualities of what you are seeing, you will find that you are also learning how to paint those edges and objects convincingly. The way you perceive and draw the edges or shapes of an object is crucial to creating the illusion of reality in your paintings, whether it's with a pencil line or painted with color and value.

TONAL DRAWING
Drawing with tone—shading with a pencil, or making an ink-wash drawing—rather than line is much more like painting. Indeed, pencil is no more than a dry pigment, similar to pastel in many respects, and an ink wash is very similar to a watercolor or thin acrylic wash. For these nonlinear drawing options, think of your tools more as paints than as drawing tools, and shift your focus toward thinking about how to capture light and its effects upon your scene: how and where it reveals value, texture, shape, form, and color. The more you practice this with your pencils and inks, the stronger and better your painting skills will become.

An especially useful method of working is to do a finished tonal

Water-soluble pencils are useful wet or dry.

drawing or ink-wash painting before starting any color work to make sure your values and composition work strongly. Good paintings do not happen of their own accord, but are crafted.

Use a kneaded eraser to create highlights.

Mechanical pencils and technical pens are easy to use. but lack variation in the lines they produce.

Colored inks can be used in the same way as black ink.

GRADED PENCILS

Soft pencils produce dark marks (right), while hard pencils produce light gray marks (left). Smooth papers create even tones, while textured papers allow a wider range of values.

EXPRESSIVE LINES

Use the edge as well as the point of your pencil to get expression in your lines, and experiment with blending, smudging, and smearing to better describe the forms you are drawing.

THREE-DIMENSIONAL FORM

When drawing three-dimensional forms it should feel as if the pencil is moving over the object itself, rather than across a flat piece of paper.

GRADATIONS

Gradations are best created using a soft pencil and starting with the darkest values. For large areas, the side of the pencil often works well, using gentle side-to-side strokes.

PENCIL AS DRY PIGMENT

Very large gradations can be achieved by shaving the edge of a graphite stick with a knife to produce graphite powder. Work the powder with a smooth cloth or your fingers.

ERASER AS A DRAWING TOOL

Learn to think of the eraser not as a tool to correct mistakes but as another drawing tool, which allows you to draw with light, rather than dark, values.

INK AND WASH

A full range of values can be created using waterproof ink on paper. Once it has dried, go over an ink drawing with ink washes to establish all the midtones.

INK AND PAINTBRUSH

Vary the pressure of your brush stroke to control the width of your lines, and experiment with different brushes, from soft rounds to stiff bristle flats and filberts, to create different textures.

DIP PENS

The irregular quality of lines made with a dip pen convey a strong sense of movement. Experiment with different textures of paper to create interesting variations in your drawings.

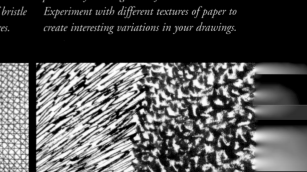
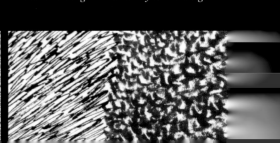

WATERCOLOR

Watercolor is in many ways the simplest and easiest of the painting mediums to use. It is quick-drying, flexible, responsive, and spontaneous, allowing the artist incredible delicacy, finesse, and control. However, it can also be one of the most frustrating, depending on your painting style.

Whole and half watercolor pans can be kept in portable palettes.

Plastic palettes are cheap and easy to clean.

ORDER OF WORK

Watercolor owes its delicacy and luminosity to its transparent nature, and preserving this transparency requires a certain degree of planning. Also, although watercolor responds well to nudging, pushing, and pulling to make it go where you want, too much of this will muddy the colors, robbing them of all life and vitality—and it may even lift the paint right off the paper. Working in watercolor requires that you follow a methodical, logical process. You will need to work from light to dark and from background to foreground. You need to lay out your composition ahead of time, and preserve the light of your paper where you need light values. Areas of strong, saturated colors will redissolve easily, and so are often left until the end of the painting.

GET TO KNOW YOUR MEDIUM

There are three primary characteristics of watercolor with which you must become intimately familiar.

- The order in which you apply one color over another will drastically alter the final appearance of the color.
- Not all colors will behave in the same way when laid onto wet paper. Some spread far and fast; others spread very little.
- Some colors are staining and will quickly and permanently soak into the fibers of the paper, while others will sit on the surface and can easily be lifted, even after the paint has dried.

To help you learn more about these characteristics, when you first start out with watercolor paint several small, quick landscapes, no larger than 8 x 10 in. (20 x 25 cm). As you work, focus not on creating beautiful paintings but on learning the characteristics of the different colors. Your aim is to reach a point where you no longer have to stop and think "will this color spread too much on the wet paper?" or "in which order should I apply these two colors?" These decisions will become instinctive after a while, allowing you to focus on the creative and intuitive aspects of your painting.

A watercolor set is small enough to be kept in your pocket.

Watercolor paper is thick to accept washes without buckling.

WATERCOLOR TIPS AND TRICKS

- Wetting only a portion of the paper will allow you to keep the paint contained in that area as you work. Think of it as building a fence around a part of your painting.

- If you wet the paper first, then almost any color can be lifted out entirely while the paper is still wet, especially the initial layers of paint.

- Use a soft tissue or damp brush to lift out color. Don't wipe or rub out color or you will damage the paper.

- Allow one layer to dry thoroughly before applying the next; otherwise, the two layers will blend into one homogenous layer.

- Using a blow-dryer will sometimes help the colors to "set," making them a little more permanent when subsequent layers are applied. However, using a blow-dryer on very wet paper will blow the paint around the paper.

- Use a kneaded eraser to erase pencil lines. Gum erasers will disturb the fibers of the paper.

USING WATERCOLORS

WET-INTO-WET

Wet paint applied to wet paper will run and flow, making precise control very difficult but allowing random, spontaneous effects. Experiment with tilting your painting board.

GLAZES

Applying one color over the top of another dry color allows light to shine through both layers of color. The result is a much more vibrant color than can be achieved by mixing the colors.

WET ONTO DAMP PAPER

Once the paper has lost its shine, fluid colors can be applied with more control but without losing the softness. Brushstrokes will soften and merge, and paint can be lifted out while wet.

DRY BRUSHING

Color which is nearly dry is gently brushed over the paper or over the top of another layer of dry paint, creating a broken, stippled look without disturbing the paint layers beneath it.

LIFTING OUT

While paint and paper are both wet, colors can be lifted out with a tissue or damp brush. As the paint dries, water can be applied to an area, and dabbed with a tissue to lift out color.

SALT IN A WASH

Sprinkling salt into an area of wet paint will create interesting textures and variations in value as the salt soaks up the water. Allow the paint to dry, then brush off the salt.

FLAT WASH

Smooth, uniform areas of color can be created by applying fluid color evenly to an area of your painting. Wet paper will increase your working time.

GRADED WASH

On wet paper, apply paint in large, even strokes, gradually diluting the paint with water on the paper to create your gradation.

MASKING FLUID

Masking fluid is used to preserve areas of white paper. Apply the fluid with a brush to dry paper. Once the painting is done and dry, gently rub off the masking fluid.

OPAQUE HIGHLIGHTS

An alternative to masking fluid is the use of opaque white watercolor. Thin to the consistency of heavy cream, and build up your highlights with several layers of white.

SPONGING OFF

Patterns and textures can be created by lifting out wet paint with a dry or damp sponge. A damp sponge will give a soft pattern, while a dry sponge will create a more defined pattern.

SCRUBBING OUT

Midtones and highlights can be created by scrubbing out paint once it has dried. Use clean water and a soft brush to create subtle effects, or a stiffer brush to create sharper lights.

ACRYLIC PAINT

Acrylic paint consists of pigment suspended in a clear, liquid polymer emulsion. In other words, acrylic paint is liquid plastic—fluid and workable while wet, but permanent once dry.

Large jars of acrylic paint are very economical.

Acrylics are an incredibly versatile medium.

THE VERSATILE CHOICE

Acrylic paint is perhaps the most flexible and versatile medium. Since water is its vehicle, or base, it can be thinned and used very much like watercolor, or applied thickly like oil paint. It is well suited to the artist who prefers to work out much of the painting on the final board, paper, or canvas, and its quick drying time and permanence once dry means it lends itself well to multiple paint layers and applications. You may even wish to explore the wide variety of gels and mediums available to thicken the paint further or add extra texture to it.

Acrylic paint is opaque enough to allow you to work dark to light, yet it can be thinned enough with water to allow you to work light to dark. Entire passages can even be painted over with white acrylic and started afresh. Just be certain to keep your brushes moist, and clean them often, because the acrylic is no less permanent in your brush than it is on the paper or canvas.

Readily available, flexible, versatile, and forgiving, acrylics are an excellent choice for artists who do not know how they wish to paint, or who would like the option of exploring both thick and thin paint applications, as well as for artists on a budget looking to explore a range of painting styles and options.

SUITABLE SUPPORTS

For those who prefer to work with thin acrylics, heavyweight watercolor paper is the best support. Work with 300–400 lb. paper, secured to a board or panel, and you will find that the paper holds up well to numerous wettings and layers of paint.

Should you prefer to work with thick paint, you may wish to use Masonite, illustration board, or canvas. Make sure that if your surface is pre-prepared it has not been prepared with an oil-based sealant. Acrylics will not stick to oils, although oils can be used over the top of acrylics very safely.

THE "STAY-WET" PALETTE

Regardless of your working process, when working with acrylics you are bound to need some form of "stay-wet" palette. This is a plastic tray palette with a layer of absorbent paper towel or cloth lining the bottom, over which is laid a slightly porous paper, similar to wax paper. Enough water will pass through the porous paper to keep the paints moist while you work, and a lid over the whole palette will keep the paints moist between painting sessions, as long as you keep the paper towel or cloth moist. You can easily make your own version with an enamel butcher's tray, several sheets of paper towel, and a single disposable palette sheet.

Stay-wet palettes are essential for preventing acrylic paint from drying up during or between painting sessions.

Buy a range of brushes for a variety of mark making.

Acrylic paint mediums and texturing agents can be added to paint for a range of effects.

Heavyweight watercolor paper is ideal for use with acrylic paints.

USING ACRYLIC PAINT

WET-INTO-WET
For watercolorlike effects, thin the paint and apply to wet paper or canvas. The thicker consistency of the acrylic will not flow like watercolor, but the look will be similar.

FLAT WASH
Acrylic paint has a uniform, matte finish, and even the most opaque color will be somewhat translucent, allowing you to build up colors and values gradually in layers.

LIFTING OUT
Interesting effects can be created by lifting out color while it's drying, with paper towels, sponges, or cloth, particularly on canvas or other nonabsorbent grounds.

IMPASTO
Thick, undiluted acrylic can mimic the look of oil paint, allowing for application with a stiff brush or palette knife, allowing you to create impasto or alla-primalike effects.

PALETTE KNIFE
The faster drying time and thick consistency of acrylic allows for thick application with a palette knife, allowing you to create very textured, thick, and luscious paint layers.

SCRAPING AND SCRATCHING
Acrylic colors can be altered by scraping or scratching while still wet, to allow the layers beneath to show, or scratches and scrapes can be painted over to enhance the textural effects.

HATCHING
Many artists achieve subtle gradations of tone and color by applying paint in cross-hatch patterns, creating a transition in the same way as you would for a woodblock carving.

ADDING TEXTURING AGENTS
Texturing agents such as thickening gels and sand can be added to acrylics as long as they contain no oils, creating a broad range of effects which will bond permanently with the paint.

BLOTTING EDGES
Soft atmospheric effects and subtle blending of the edges of objects can be created by gently dabbing or blending the wet paint with a damp brush, soft cloth, or your fingers.

WATER SPATTERS
Partially dry paint can be spattered with water and left to dry, creating subtle areas of diluted pigment, or else dabbed with a paper towel, lifting out the wet areas more thoroughly.

DRY BRUSHING
Wipe most of the paint off your brush with a rag; once the brush is mostly dry, drag it across the canvas. Paint will adhere to the "peaks" of the textures, allowing colors beneath to show.

GLAZES ON DISTRESSED PAINT
To bring out the scrapes, scratches, and textures in your painting, experiment with glazing an area with very fluid paint, which will settle into the depressions you've created.

OIL PAINT

Oil paint is more complex and difficult to use than watercolor or acrylic paint, but offers the artist a much wider range of options and possibilities. Oil paint stays wet for much longer than watercolor or acrylic, giving you considerably more time to model and work the paint, and there is no limit to the number of layers you can apply. Unlike watercolor or acrylic, which use water as the vehicle (which evaporates as the paint dries), oil paint uses oil as both the vehicle and the binder. When dry, the oil is still present, giving a luminosity, depth, and richness to the paint that other mediums cannot match.

Portable oil painting sets.

A CLASS OF ITS OWN

Oils can be used in a number of ways: thickly, as they come from the tube; thinned considerably with an oil medium, to create the most delicate and subtle of glazes; and anywhere in between. Once a layer has dried, additional layers can be applied without disturbing the ones underneath, allowing you to gradually build the colors and values in your painting into something subtle and delicate, yet strong and dynamic, with a finished look unmatched by any other medium.

THE EXTRAS

There are a plethora of mediums, driers, varnishes, additives, and the like available to the oil painter, but for the beginner, the recommendation is to start simply. Avoid the use of linseed oil (a cheaper and less effective oil) and turpentine all together. Walnut oil makes an excellent starting medium, for it cleans up without turpentine and dries to a clear, strong, and flexible film.

Dedicated brush cleaners are recommended for general brush cleaning and conditioning.

As you get more comfortable with oils, feel free to explore some of the many mediums, varnishes, and additives available to you, but if in doubt, walnut oil all by itself will see you through years and years of painting.

CHOOSING YOUR GROUND

Oils can be applied to canvas, wood panels, or very heavy illustration board. You need a ground that is not too flexible, and the surface must be sealed with a primer—acrylic gesso is the most common. Apply several coats, to be sure that the surface is completely sealed, otherwise the ground will absorb the oil from the paint, turning it into nothing more than powdered pigment that falls off the painting. You will notice that initial layers will dry more rapidly than subsequent ones, because the primer is somewhat absorbent.

FAT OVER LEAN

There is one inviolable rule when working in oil paint: paint fat over lean. This means that each layer you add must contain a little more oil than the one before it, because deeper layers will soak the oil out of upper layers as they dry. Work from dark to light, building up the lighter values with thicker, opaque paint, to give the light tones body and substance. Let each layer dry completely before adding the next. The colors and values of your paint will shift slightly when dry, but you can compensate for this by oiling out your board when you start each session. To do this, pour a small amount of clean oil onto the painting and, with a very soft cloth, spread it gently around until it forms a very thin coating over the whole piece. You are now ready to paint again. This process will also help to maintain a fat over lean painting.

Varnishes used over a finished painting can give a high-gloss finish.

Oil paints are available in both tubes and cans.

Linen (left) and cotton (right) canvases are suitable for oil painting once primed.

Dippers containing mediums can be attached to a palette.

USING OIL PAINT

ALLA PRIMA
Alla prima, or "all at once," painting is the most direct, spontaneous method of paint application for oils. Paints should have a thick consistency, allowing for smooth, easy mixing.

SFUMATO
Sfumato, from the Italian "blended" or smoky, is the use of many layers of translucent paint (glazes), blending colors and values so subtly that there is no perception of transition.

PAINT DABS
Paint strokes applied over a wet base will tend to soften and blend with the underlying color. Brushstrokes applied to a layer of dry paint will be crisp and sharply defined.

BROKEN COLOR
One color applied over another in a broken layer allows the color underneath to show through. The result is that both colors are perceived and then mixed by the eye.

TRANSLUCENT LAYER
This is a smooth, partially transparent layer of paint which allows the layers beneath to show through. This creates a soft, muted look, lacking the clean intensity of a glaze.

GLAZES
A glaze is a layer of transparent paint applied over another layer of transparent paint so that light can pass through both layers and reflect off the canvas beneath.

SCRATCHING AND SANDING
Dry paint layers can be scraped, sanded, and scratched with a variety of materials to create very interesting, often subtle textures and effects.

UNDERPAINTING
Underpainting allows you to establish the values in your painting, independent of local color. Warm browns, blues, or grays are most often used for landscape painting.

DISTRESSING WET PAINT
Wet paint can be distressed to create interesting effects. Try scraping with a palette knife, scratching with wooden tools, blotting with a cloth, and pushing with the end of a brush.

THE PAINTING SURFACE
Canvas (right), will hold paint in place strongly, and allows thick layers of paint to be applied. Smooth surfaces such as Masonite (left) are ideal for thin paint applications and glazes.

PALETTE KNIFE
The palette knife stroke is very distinctive: crisp and clean along three sides, but blended and ragged along the fourth, where the paint is dragged across the colors beneath it.

GLAZES ON DISTRESSED PAINT
Textures can be enhanced by glazing color over them once they dry, then gently rubbing the glaze with a soft cloth. Paint in the depressions will remain, while the rest is removed.

WORKING DIGITALLY

Your choice of computer is your preference. Apple Macintosh is the preferred system among digital drawing professionals, but most software is available on both Mac and PC. Most PC operating systems include a program that allows you to draw, paint, and edit images. Microsoft Paint, for example, is part of Windows, and although primitive, is a good place to start experimenting with digital drawing. Scanners also include a basic photo-editing and drawing package, or a reduced version of one of the more professional packages.

EQUIPMENT

Vital equipment includes a scanner on which you might scan your own sketches for digital coloring, scan photographs and found images, or actual objects. Also useful is a stylus and drawing tablet. Drawing with a mouse can be awkward and clumsy because it is held quite differently from a pencil or pen, whereas a stylus replicates the natural drawing movement.

DRAWING AND PAINTING MEDIA

Any software designed for drawing and painting will provide a range of tools, from pens, pencils, pastels, and colored pencils to various brushes. Programs vary, but most have a swatch tool you can pick colors from. The eyedropper tool enables you to select a particular color from your picture for use elsewhere in the composition. The dodge and burn tools in Photoshop enable you to lighten and darken previously painted areas of color and create shadows and highlights.

When learning a new piece of software, familiarize yourself with the different

tools and their effects by doing some doodling with them. You may find it easiest to draw an initial sketch by hand on paper and then scan this image in to be digitally colored.

LAYERS

Most drawing, painting, and photo-editing programs allow you to experiment with different effects and compositions by using layers. Layers can be visualized as pieces of transparent film stacked on top of one another. When you make a drawing, or scan in a photograph, it appears as a background layer called the canvas. If you create a new layer on top of this, you can work on it without altering the underlying image because the layers are independent of each other. Similarly, you can work on the canvas without affecting any images on other layers.

DIGITAL IMAGING PROGRAMS

Photoshop Top-of-the-range, flagship digital editing program. This is the one the professionals use. However, this kind of sophisticated digital tool doesn't come cheap at over $500.

Photoshop Elements This is Photoshop's little brother, incorporating many of the features of the full program. This is a good entry-level tool at $100, but you'd probably want to move up to the full Photoshop eventually. Often bundled for free with higher-end scanners.

Paintshop Pro Well-made digital imaging program which offers almost all the features of Photoshop for a fraction of the price (less than $100). The drawback is that the program is Windows-only.

Painter This program is favored by those who come from a traditional paint-on-paper background. It's especially designed to mimic the more painterly (hence the name) effects, like paint on wet paper, and includes features like hundreds of different types of virtual brushes and a palette you can actually mix colors on.

Bundled scanner software Very few bundled digital imaging programs that come with scanners are much use for anything other than resizing or cropping images, with the exception of Photoshop Elements.

Bryce This is a quite amazing imaging program which can create (almost automatically) stunning, fully rendered 3D landscapes. The resulting images can be viewed from any angle, zoomed in on, and even flown through as if you were in a helicopter.

Poser A highly useful program which creates 3D human figures that can be posed (hence the name), clothed, then viewed from any angle. It's possible to buy add-on packages that allow you to create 3D animals, as well.

PHOTOSHOP BRUSHES

When you are using the brush tool in Photoshop, you can set the type of brush and size in the brush toolbox. To view this, click "Brushes" in "Windows" on Photoshop's top tool bar. The green marks represent different airbrush sizes. The blue marks show a marker pen-style brush. The pink marks show the more unusual brushes that produce a particular preset shape many times.

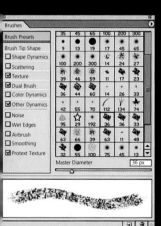

USING LAYERS

One of the most useful functions in Photoshop is the ability to put different elements on different layers. The layers window (see above) allows you to turn the visibility of each layer on or off and to adjust transparency using the opacity percentage slider. A number of tools are available to select various parts of the image, all of which are found on the toolbar (1). The marquee tool (2) is useful for simple geometric shapes, the lasso tool (3) for drawing around chosen areas, the magic wand (4) for

selecting areas where the color or tone is distinct, the picker tool (5) to sample a color that is linked to a selection dialog box, which allows you to adjust the range of the selection through the fuzziness slider, and the quick mask tool (6), which allows you to paint a selected area.

2

- Rectangular Marquee Tool
- Elliptical Marquee Tool
- Single Row Marquee Tool

3
- Lasso Tool L
- Polygonal Lasso Tool L
- Magnetic Lasso Tool L

5

- Eyedropper Tool I
- Color Sampler Tool I
- Measure Tool I

JARGON BUSTER

Scanning The process of digitizing printed or other paper-based images into digital files, usually by means of a flatbed scanner.

Importing This is the transfer of text, images, or other data from one program to another.

Changing image size Digital images can be reduced or enlarged, for example, a scanned thumbnail sketch can be enlarged to form the basis of the finished painting.

Making selections This is the digital equivalent of cutting out a shape with scissors in order to isolate an area of an image that you want to work on.

Layers A vital feature of digital imaging is the ability to stack transparent layers. Higher layers overlap lower, preserving the capacity for each to be edited separately.

Flattening files This is the name given to the process of combining all the layers of a digital image into a single layer, usually for delivery to a publisher or to prevent the image from being edited further.

RGB This emulates the way in which light of the three primary colors (Red, Green, and Blue) can be combined to produce any other color.

CYMK This color format produces different colors by mixing four base pigments—Cyan, Yellow, Magenta, and Black (labeled "K" so it won't be confused with Blue)—in the same way printing on paper does.

Grayscale Real color converted to monochrome in the style of black and white photography.

INSPIRATION

Inspiration can come from anywhere. A snippet of conversation, a favorite book or movie, something glimpsed out of the corner of the eye, a trip to the zoo, or just a walk in a park or down a city street.

Anything that makes you ask that all important question "What if?" can be used in your work. What if you added this to that, or juxtaposed these elements? What if you took reality and twisted it like this?

However, for any of these bolts of lightning to strike home, they need somewhere fertile to land. That requires three things.

First, a thorough knowledge of the fundamentals of picture-making is needed. Whatever your medium, regardless of whether you paint representationally or not, the basic rules of composition, color theory, lighting, and such are the same. These rules are not hard and fast, nor can you simply follow them formulaically or mechanically

and produce a good painting, but if you don't know them, you will find yourself adrift, unable to create the image you want, and unable to discern why. These rules are tools, and are every bit as important as a brush or canvas.

Second, if you are going to paint representationally, you must be a keen observer of nature. Representational painting is nothing more than learning to see clearly and objectively.

The last requirement is your own artistic vision. It is not enough to simply attempt to capture or recreate nature like a camera. What makes a painting truly memorable and successful are all the choices and edits that the artist makes. If these changes are based on a thorough understanding of the rules of art and an understanding of the real world, then they will be convincing, compelling, and memorable. This is especially important for the fantasy or science fiction artist, who is trying to create a world that does not exist, but looks as if it could.

INSPIRATION

Stuck for ideas, not sure how to kick start the brain? Here are a few suggestions to help when you seem to be stuck in neutral.

1 Get your feet moving. The constant visual stimulation of a walk down a street or in a park will get your mind going as few other things can.
2 Visit a museum or gallery. Challenge yourself to find a new artist you like, be it Old Master or contemporary.
3 Books, movies, and television can generate ideas and throw together concepts that you might not otherwise link together. Watch television with the sound turned off, or rent a foreign film and turn off the subtitles.
4 Flip through your old sketchbooks. Interesting, partially formed ideas will leap out at you, often combining to form new inspirations.
5 Watch children draw and paint. The immediacy and spontaneity is infectious.
6 Draw for fun—attend a drop-in drawing or painting session at a university or art store, and have fun without the pressure to produce something perfect.
7 Change mediums. Sculpt something out of clay or carve a piece of wood to get the mind going.

▼ ILLUSIONARY TERRAIN
Out of the need to create an illustration of one landscape taking on the appearance of another came this odd visual illusion. A subtle juxtaposition and transition allowed the blending of ice and water themes. Careful observation of snow and water, repetition of lines and shapes, and a subtle handling of the paint all give solidity to the forms and the composition, and make the illusion convincing.

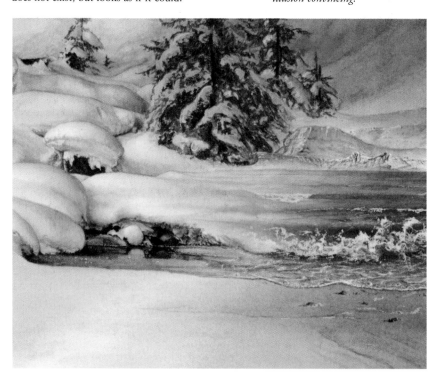

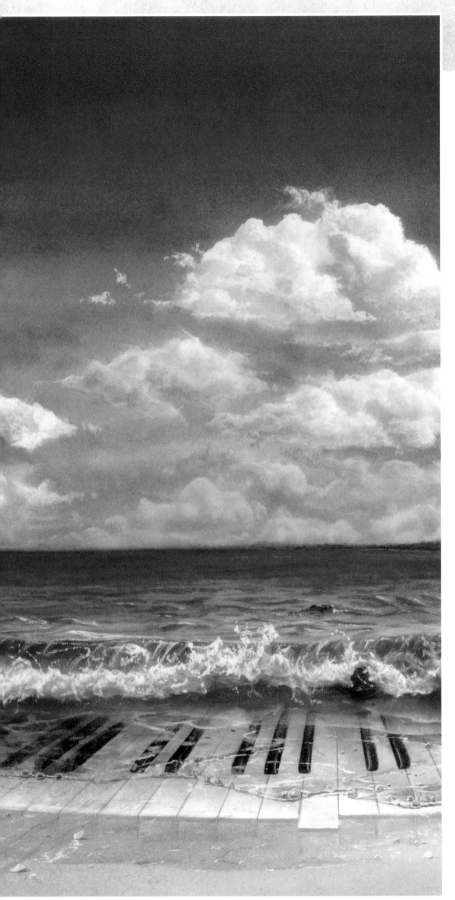

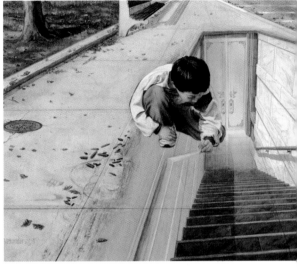

▲ TWISTING THE REAL WORLD

This is a wonderful example of taking the real world and giving it a subtle but strong twist, and creating something unexpected as a result. Starting with the basic premise that what the boy was drawing was actually becoming real, he is then painted as if he were still firmly resting on the sidewalk. That impression is sustained, even after you realize that there is nothing beneath him, and he looks to be hovering above the steps he is drawing. The subtle suggestion of the sidewalk continuing over the steps, the gradual fading of the steps into a flat chalk drawing on the concrete, and a unity to the lighting all contribute to the illusion.

◀ NATURAL RHYTHMS

The ocean has always struck the artist as musical, a never-ending symphony, but how does one represent that visually? The answer seemed clear once the right question was asked. How does one show the ocean making music? A wave washing over a keyboard, playing music, conveyed the idea most clearly, and after that, it was a simple mater of juxtaposing the two elements into a strong composition.

USING REFERENCE

There's no substitute for direct observation of the real world if you want to draw and paint accurate representations.

Whether you paint the view out of your window exactly as it is, or use it as a springboard to launch your mind to an alien planet, if you choose representational painting, you are trying to convince the viewer that the world you have created is real, and that means real in the ways we recognize, understand, and relate to our own world.

SKETCHING

Learn to carry a sketchbook or paint box with you wherever you go. While a full palette and setup is impractical, it is fairly easy to manage a small sketchbook and a handful of pencils, charcoals, or felt pens. Work on tinted paper so that white can easily be used to capture the main dramatic lights of the scene. Or try a travel watercolor kit—a small block, limited palette, a couple of travel brushes, and a plastic water container fit easily into many bags, as do a few 35 mm film canisters of acrylic paint. Black, white, and a warm and cool mid-tone gray allow a wide range of possibilities, but are portable, and almost anything plastic will serve as a palette. When you're done, just let the palette dry, peel off the dry paints, and you're ready to go again.

Learn to capture what is important in what you see. Record values and large shapes, and make notes on the colors and textures, so that later in the studio this visual diary will give you the information you need to recapture that initial spark of inspiration.

USING A CAMERA

A camera, preferably digital, can also be an excellent tool in the field, but be aware that cameras flatten and distort what you see. When you draw from life, you are forced to choose for yourself how to translate the original subject to a flat, two-dimensional surface. Also, be wary of becoming too reliant on photos because that will make you a slave to your reference. It's all the leaps of imagination and the editorial choices you will make as an artist that will make your picture truly memorable, not how faithfully you can reproduce your photo reference.

RESEARCH

Once you get back into the studio, it's time to supplement the information in those sketches and studies with whatever else you need to bring your vision to life. Place flowers into a vase on the drawing table to study them more closely. Gather photos of gothic ruins to study the texture and feel of the rough stone walls. Take a trip to the hardware store to get examples of odd metal shapes, and study the reflections so your spaceship looks right. Whatever you need in order to understand the elements in your painting, don't be shy about obtaining them. You can only paint what you know, and if you don't know enough about something, you owe it to yourself to find out before you do that drawing or painting.

Books, be they travel, reference, or copies of Old Masters' paintings, can be a valuable source of information. Just remember that these images will all be copyrighted to someone else, which means you can study them, glean information from them, or paint your own private copies to learn more about a subject, but you cannot use them in such a manner that the average person would recognize the original source of reference in your final work.

▲ USING PHOTOGRAPHS
The photographs helped with the creation of the final image (opposite page, top), but the painting is not simply a literal copy of the photos. Learn to rely on your own experiences and allow them to become the driving force when you paint. Photographs will help you remember details in structure or texture, but it is only your own internal compass that can truly tell you when something "feels" right in the piece, at which point it's time to stop, regardless of whether the painting matches the photograph.

▶ REAL-WORLD OBJECTS
Whether you gather odd bits of metal from a hardware store or cover your drawing table with flower petals, bones, fabric, or anything else, there is nothing better for the artist than direct observation. What you don't know, you cannot paint.

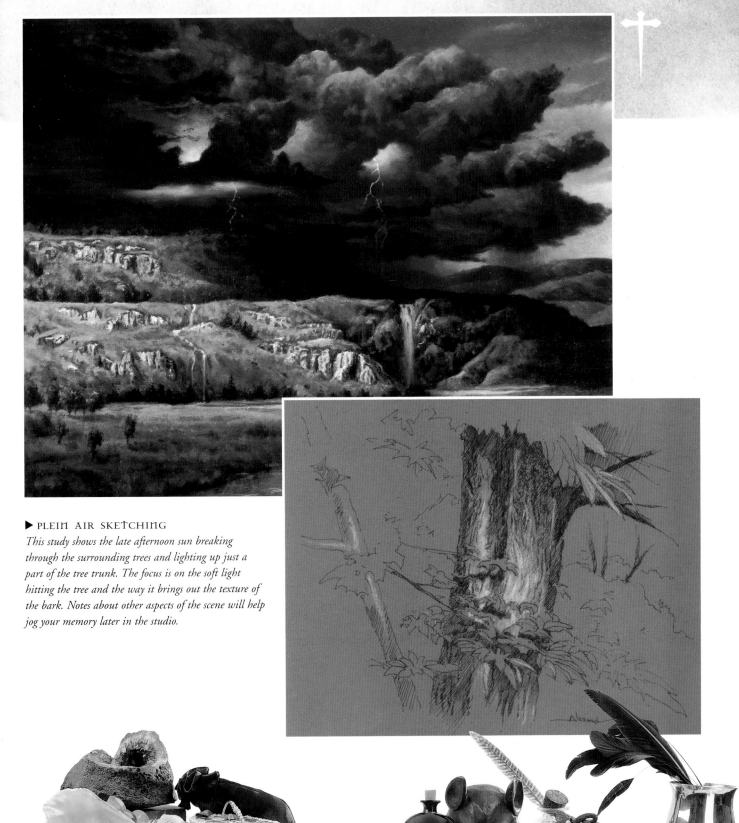

▶ PLEIN AIR SKETCHING

This study shows the late afternoon sun breaking through the surrounding trees and lighting up just a part of the tree trunk. The focus is on the soft light hitting the tree and the way it brings out the texture of the bark. Notes about other aspects of the scene will help jog your memory later in the studio.

SKETCHING

Sketching is the most important part of the painting process for several reasons. Only by drawing from life is it possible to begin to understand the real world well enough to paint it convincingly. Pay specific attention in your sketches to the rhythms and patterns of objects, such as the step-like shelves of rock in a mountain. These patterns will show up again and again, and once you understand them, you can begin to really work with them, creating places out of your imagination.

You should also use the sketching process to figure tonal values (the relationship of lights and darks to each other). These are the most crucial element in any painting— if the values don't work, objects will lack structure and three-dimensionality, and the painting will not have visual rhythm or movement. Color is secondary to value, and no amount of color work will compensate for poorly realized tonal values.

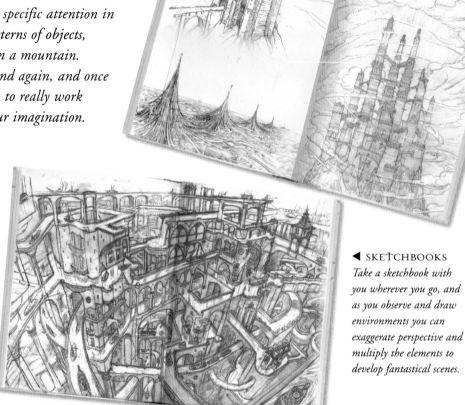

◀ SKETCHBOOKS
Take a sketchbook with you wherever you go, and as you observe and draw environments you can exaggerate perspective and multiply the elements to develop fantastical scenes.

ORIGINS OF THE PAINTING

Like a lot of fantasy landscapes, this one started out with "that looks OK, but what if I did this to it?" That leap of imagination allowed the artist to visualize a ruined tower on a mountain top and then alter elements of the drawing in order to make it work. He describes the conceptual process as being like a jigsaw puzzle in his head: when he understands how things really look, he can start rearranging those jigsaw pieces, creating places that don't exist, but look as though they could.

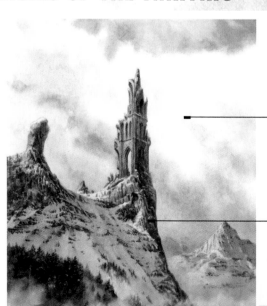

THE COLOR PALETTE
The final painting uses hot-pressed watercolor paper and Graham watercolors (made with honey, not sugars, so that they rewet and dissolve better than most paints).

Clouds are mostly viridian green and burnt umber in the shadows, to reflect the tree and rocks beneath them. The sky is cobalt and phthalo blue to give it a coldness and intensity, as is the snow.

Burnt umber is used for the rocks, with ultramarine added to the shadows and raw sienna in the lights. Dark trees are viridian, burnt umber, and ultramarine blue.

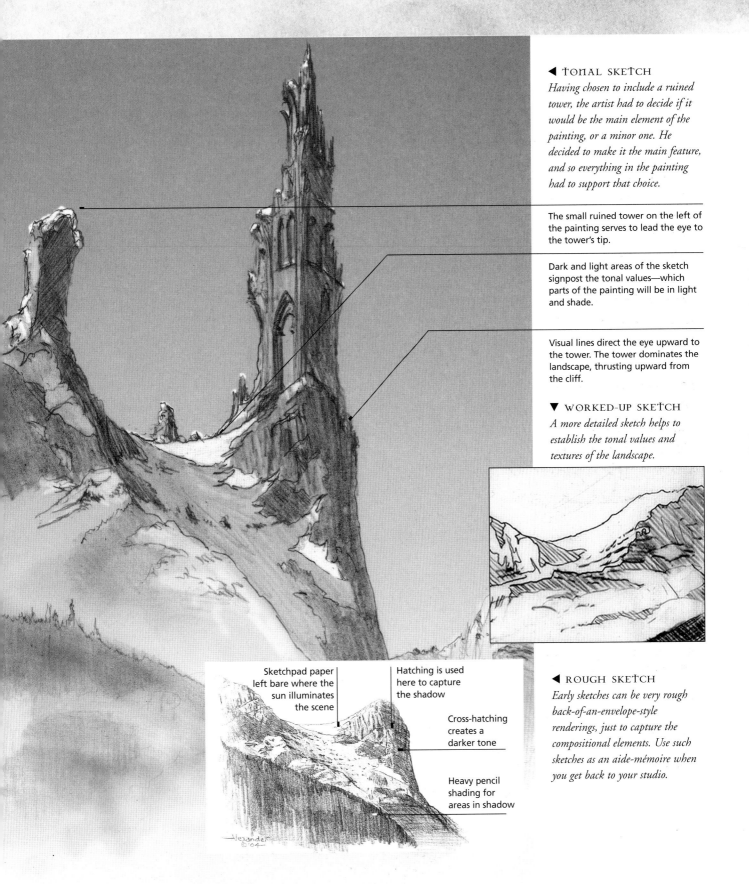

◄ TONAL SKETCH

Having chosen to include a ruined tower, the artist had to decide if it would be the main element of the painting, or a minor one. He decided to make it the main feature, and so everything in the painting had to support that choice.

The small ruined tower on the left of the painting serves to lead the eye to the tower's tip.

Dark and light areas of the sketch signpost the tonal values—which parts of the painting will be in light and shade.

Visual lines direct the eye upward to the tower. The tower dominates the landscape, thrusting upward from the cliff.

▼ WORKED-UP SKETCH

A more detailed sketch helps to establish the tonal values and textures of the landscape.

◄ ROUGH SKETCH

Early sketches can be very rough back-of-an-envelope-style renderings, just to capture the compositional elements. Use such sketches as an aide-mémoire when you get back to your studio.

Sketchpad paper left bare where the sun illuminates the scene

Hatching is used here to capture the shadow

Cross-hatching creates a darker tone

Heavy pencil shading for areas in shadow

USING ROUGHS

So, that elusive bolt of lightning has struck, catching you in the shower, or on a date, at the drawing table, or even waking you from a sound sleep. Now, what do you do with it, and how do you capture it?

The short answer is to get it down in any way you can, with whatever medium you are comfortable with. Some of the most common choices are felt pens, acrylic paint, watercolor or gouache, or a good old-fashioned pencil. Whatever your choice for that particular idea, pick something that meets two basic criteria. You must be comfortable with the medium, so that it can be transparently responsive to your thoughts and needs, and it must also be suited to what you are trying to convey. Whether you are capturing your initial idea or crafting the finished piece, you must be comfortable with your medium to the point where you don't think of it at all—you just draw or paint with it, knowing on a subconscious level what to expect from it and how to make it do what you need it to do. This is not to say you should become complacent about it, or think you know everything. You need to continually experiment, challenge yourself, and, above all, have fun. You don't want to find yourself struggling to make the media you have chosen to use do something, and as a result getting so caught up in the struggle that you lose the idea or the enjoyment of making the art in the first place.

Watercolor, which is a very responsive and flexible medium, can capture a lot of ideas in a few minutes. The heart of the idea is there: lighting, value, shapes, and composition can all be captured very quickly. At other times, a large black or sepia marker is just the tool for the job. The important thing is to let the tool become invisible and instinctive.

▲ MARKERS
Fast, versatile, and portable, markers can be a great way to capture an idea. Try sketching at first with a very faint marker, letting the idea form on the page. As you continue to refine the drawing with darker values, anything from the initial stage that you don't like will drop out, or get overdrawn and disappear, leaving you with the idea you wanted to express.

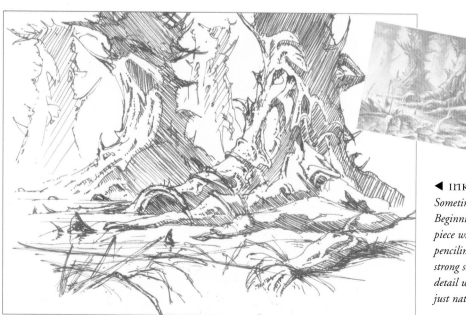

◀ INKING
Sometimes it's best to just let an idea develop. Beginning with some of the foreground elements, this piece was allowed to develop with no preliminary penciling at all. Masses became simplified shapes, a strong sense of interlocking forms began to emerge, detail was subordinate to the shapes, and the picture just naturally evolved.

EXPERIMENTING WITH DIFFERENT MEDIA

At this stage do not get bogged down with studying reference materials or worry about making the composition perfect. These can all come later. What you need first is to trust your own inner eye, and capture the core or heart of your idea as purely as you can with as little outside influence as possible. Looking at photographs or other reference materials too soon can rob you of some of your creative spark and dilute your idea.

Featured on this spread are some roughs and sketches in different media, each chosen for its own strengths and reasons. As with any advice, the best thing you can do is take it with a large grain of salt, try it a few times, and take away what works for you. Experiment, find your own solutions, and refer back here if you find yourself stagnating or stuck in a rut.

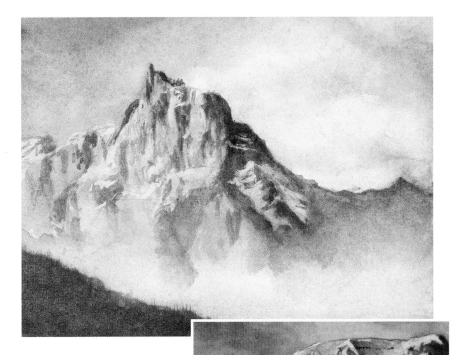

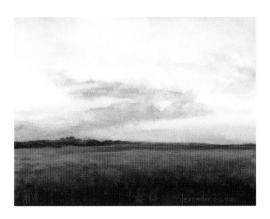

▲ WATERCOLORS
This was a very quick sketch. After 15 minutes the artist had an idea of how the colors would relate to each other, and the values and palette were worked out. Since the final painting was intended to be done in watercolor, sketching in the same medium allowed the artist to learn how the colors would behave on the paper. Anything that was going to overpower the other colors, or run and spread to a point where control was lost, became apparent right away.

▶ SHAPES AND VALUES
These two very quick, simple mountainscapes were done with watercolors. They have a strong sense of mass and solidity, with the value relationships worked out and the basic palette established, all in about ten minutes. Watercolor's quick drying time and spontaneity makes it an excellent choice for quick sketches like this.

▼ COMPUTER SKETCHING
The computer is a fast, flexible tool. After a number of very quick sketches that explored all the elements in the piece, three were selected and scanned into the computer at a low resolution. Large, simple gradations of color and some very quick airbrush effects were added in order to capture the mood—that first overall emotional impact that the image would have on the magazine rack or bookshelf.

COMPOSITION

Composition is the arrangement of light and dark shapes, and of lines and values on the page or canvas. Like a good piece of music, there must be rhythm, movement, and balance.

For the artist, composing an image begins with two important steps. First, you have to become aware of what makes a good or a bad composition. On the following pages are several studies, explanations, and examples of compositional elements. They are abstract, in that they do not represent recognizable objects. They are simply the arrangement of lines, shapes, and values on a page. Study and learn them until they become ingrained, and play around with designs and variations of your own. Soon you will have reached the point where placing the elements on a page becomes second nature to you, and you no longer have to think consciously about the rules of composition.

After a short time spent creating your own compositions, you will begin to notice that even though you are not drawing recognizable objects, there is still an emotional element in your designs. A series of flat horizontal lines feels tranquil, while diagonal lines and shapes suggest movement. Swirls and spirals hold the eye, short marks give off a sense of energy, while long ones give a sense of calmness.

GRID GUIDE

The four marked points are "safe" zones for a center of interest in your composition, and the two horizontal lines are good divisions for the horizon line, giving your piece either $1/3$ sky and $2/3$ ground plane, or $2/3$ sky and $1/3$ ground plane. These aren't the only solutions, but they are a good place to begin.

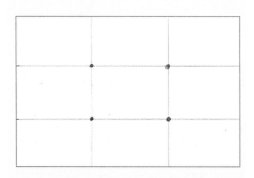

TREES IN COMPOSITION

Open, calm, and inviting, focus is on the open space in the foreground.

Focus is on what might be possible once you get past foreground trees.

Focus is on space between the trees, waiting for something to happen.

▼ RHYTHMN

Always try to create a rhythm in your composition that leads the eye into and around the picture, and create interest by varying shapes and balancing tones. Below are some simplified examples of "good" and "bad" composition.

Good—calm, gentle "steps" into the distance create depth.

Bad—eye forced to edge of the page and right off.

Good—eye stays within the closed triangle; dark and light values keep the eye moving.

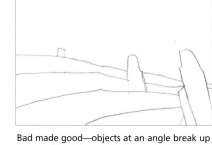

Bad made good—objects at an angle break up lines and lead the eye back into the image.

Good—active, constant movement between three points of the open triangle.

Bad—eye led to edge of the page and stops. No rhythm or movement.

Energy, direction, and movement through mark making.

Shapes creating movement, focus, and tension.

Circles hold the eye or move the eye inward.

▲ MOVEMENT

The nature of your marks by themselves can convey energy, direction, and motion, creating rhythm and flow even without a recognizable subject. Similarly, shapes and values will convey movement and direction, allowing you to create rhythm and lead the eye so that the viewer sees what you want, when you want them to.

A NOTE ON MOTION

All motion can be described as being either potential or kinetic. Think of potential as motion about to happen, while kinetic is motion in the act of happening. Potential motion in your image can create a strong dynamic tension because the viewer expects the object in question to move, and move soon. Therefore, tension, anticipation, and excitement can be generated. With kinetic motion, the viewer will have a tendency to project forward in time to the cessation of movement of the object—anticipating the collision of two objects, or moving the eyes to the bottom of the canvas as objects fall.

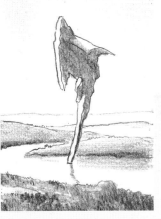

Eye anticipating movement but unsure where, so eye moves throughout entire composition.

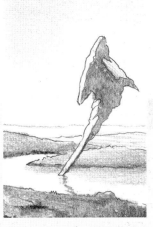

Our eye tells us the object must be moving. Eye moves to the area it anticipates the object will occupy.

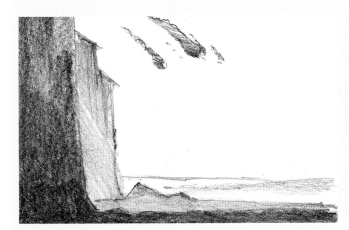

With the objects at the top of the picture plane, the focus is on the area they will move through, and the action of the piece becomes all about the objects moving through this space. The eye wants something within this area to focus on. Used often in movies to force the eye to follow the movement of an object.

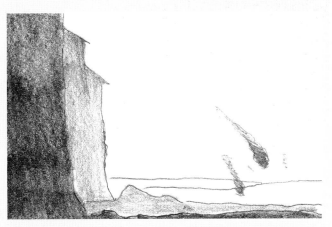

Objects are now near the ground, and the focus becomes the point and moment of impact. The eye locks onto the ground where the impact will occur, even if there is no object there to hold our attention. Used a lot in movies to lead the eye to a person or object situated at the point of impact.

▼ EMOTIONS

Look for ways to use scale, value, rhythm, and placement to create different emotions within your compositions. Even simple compositions such as this tower and field can convey a wide range of emotions. The emotional component of your composition will have the strongest impact on the viewer, so you must be clear what this is, and you must find the solution that most powerfully communicates it.

An emotional impact or aspect comes across even in compositions that are abstract. You must have a clear understanding of what you want the picture to convey emotionally as you design it. It may be clear before you pick up a pencil or brush, or you may discover it as you go, but either way, your composition must strengthen and support it, or else you will find it working against you.

Remember, as you work out your composition, that details, surface textures, and small shapes are all unimportant in the early stages. Avoid having too many areas of similar size or shape. Look for values that are similar and can be massed or joined together. If you are stuck, then start with massing the shadows first. Keep your compositions small at first. Many artists work out the basic composition of a potential painting in a "thumbnail" sketch, so called because it is seldom larger than 2 x 2 in. (5 x 5 cm).

As you enlarge and refine your composition, remember that our eyes are drawn to areas of light. The shadows in your image should not have enough variation in value or color to hold the eye or make us pause, whereas it is essential that the light areas do contain a wealth of detail and texture to hold and satisfy the eye.

When you are done, ask yourself if there is even one element that could be added or removed from your composition without making it less effective. If you answer yes, then you must decide if the change means the picture is incomplete, or if the change represents personal choice. If the answer is that the design is simply incomplete, then continue to refine the composition until you can no longer make any changes to it without making it less than it was.

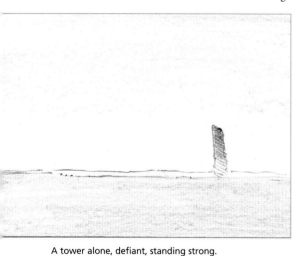

A tower alone, defiant, standing strong.

Strength exposed—perhaps a lone watch tower. Marooned, desolate, abandoned.

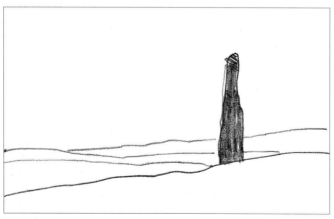

Looming, overshadowing strength, inviting exploration.

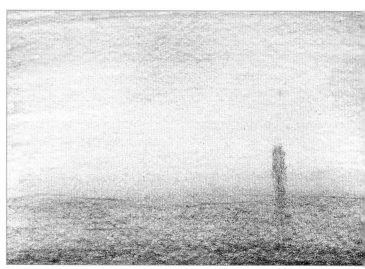

Sad, lonely, desolate.

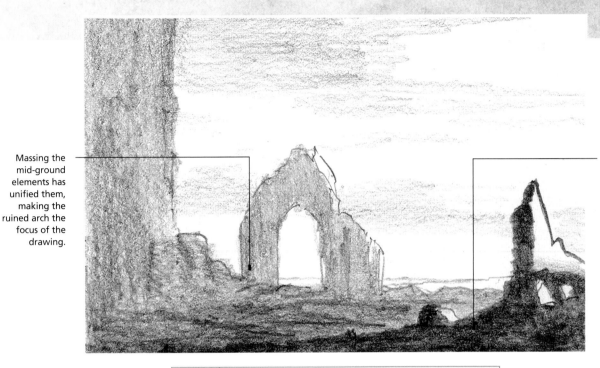

Massing the mid-ground elements has unified them, making the ruined arch the focus of the drawing.

The foreground shadows have also been massed, separating them from the mid-ground.

▲ ▼ MASSING

Massing is the grouping of similar values into larger, unified shapes that strengthen and simplify your composition and make the shapes and objects read more clearly. As you draw, look for shapes which can be combined to strengthen your image. A linear drawing may be the first method of composing that you try, but it will not be the most effective. Value is what reads first and most clearly in your painting.

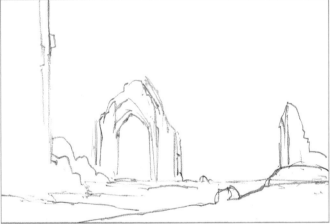

A good composition, all the elements worked out, but no clear sense of the focus of the drawing.

The shadows are unconnected and don't describe the forms clearly.

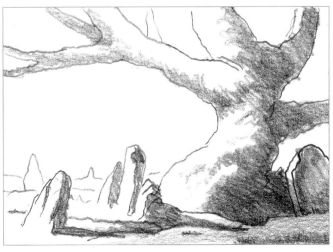

Massing the shadows creates shapes that read clearly and describe the forms.

VALUE, LIGHT, AND SHADOW

Painting is all about light. You are not painting an object, you are painting what happens when light touches the object, or the absence of that light, in the shadows.

Value, the range of light to dark in your image, is the single most important factor in making what you paint look real, solid, and three-dimensional.

SHADOWS DESCRIBE FORM

Without shadows, there can be no volume or three-dimensionality to your painting, and without light, there can be no shadows, only darkness. If you were to reduce the deepest shadows in your image to flat black, and everything else to white, then those black shapes must clearly begin to show the forms as three-dimensional objects. A true illusion of volume and three-dimensionality requires careful modulation of the midtones, but they must be built on a foundation of strong, clear shadow shapes. You may look at a scene and observe cast shadows or other strong shadows that would distract from or confuse the sense of three-dimensionality in your image, while others will strengthen it. Evaluate and edit what you see in real life so that you can discard what does not work and make the best use of what does.

SIMPLIFY THE SHADOWS

It is the act of light striking an object and then being redirected to your eyes that enables you to see the object at all. The less light redirected to your eyes, the less information you will see. This rule is true whether the light is soft and diffuse, hard and crisp, or anywhere in between. In translating what you see, or the lack of it, to the page or canvas, you must understand that light equals information. Learn to think of your brush as a flashlight, moving across the canvas and revealing the objects.

Where light is very bright, you may find that so much of it is redirected to the eye that most of the information about the object is lost. The color of the light may affect the air around the object, seeming to bleed off the object into the surrounding space. However, that bright light will quickly give way to midtones. It is in the midtones that the true color of the object and nuances of surface texture are revealed.

▼ **SHADOW FOUNDATION**
The shadows have been reduced to light and dark, with very little midtone, in order to establish the shadow shapes clearly. The foundation of your painting must be complete before you add details.

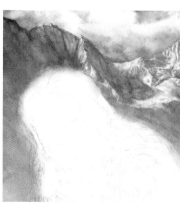

▼ **ADDING THE DETAILS**
The rocks jutting out of the snow will make the mountains look like mountains, but only because the structure of the mountain, the shadow shapes, have been established firmly and convincingly.

▼ **FROM LIGHT TO DARK**
The highlight on an object will tell you about the color and nature of the light—soft or hard, strong or weak. The midtones of the object, those areas which are not the most strongly illuminated, but not shadows, will be where you see the most information about the object itself, such as its true color and surface texture. The shadows will describe the shape of the object and allow you to see it as a three-dimensional object.

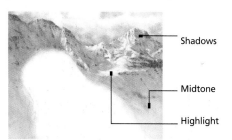

Shadows

Midtone

Highlight

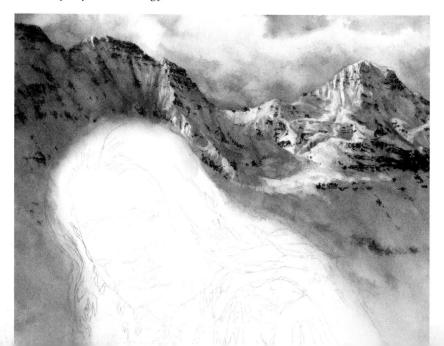

As these midtones gradually move away from the light source, less and less of the light reaching those parts of the object will reach your eyes, and so more and more information about the object is lost, until finally you pass into the realm of shadows and all that can be perceived are basic shapes, a limited range of colors or textures, and only the strongest of value shifts. Less information reaches your eyes in the shadows, so they must be rendered in broader, simpler terms (see the panel on p. 33).

BE CONSISTENT

This does not mean that your entire image must be uniformly lit, nor that you should make the light exactly the same throughout, but you must be aware of the strength, direction, and nature of your light. If you have a strong light striking an object, then the light that passes the object and strikes the ground nearby must be of a similar intensity. It is not exactly the same, however, as you must also allow for subtle changes in the distance from the viewer, reflected lights, and atmosphere; but the light must be similar or objects in your image will not look as if they are in the same painting.

Think of it as a hierarchy of your lights; from King, Queen, and Prince down to Farmer and Peasant. The further an object is from a light source, or from you, the weaker its light will be.

It is the consistency of light across the various planes (up, side, etc.) working in conjunction and balance with the light hierarchy that will truly make the lights and values in your painting convincing.

You are free to use several different light sources in an image. Perhaps a shaft of sun breaking through the clouds will give one part of the painting a strong, bright light where the rest of the image is duller and less intense, or a cacophony of intense neon lights could illuminate your city street, or a castle interior

could be lit by several flickering torches. The important thing is to handle them all consistently.

Keep in mind that there should be only one main source of illumination—the primary light source; any subsequent lights must be secondary. You may have as many lights as you want, but one of them must dominate, or else they will compete too strongly, confusing and flattening out your image.

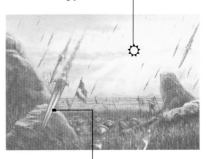

With the light coming from above and behind, the planes which face upward are the most strongly illuminated.

The blades glow with their own light source. This light is the same color as the sky; this suggests a translucency to the blades, and creates harmony and consistency in the painting.

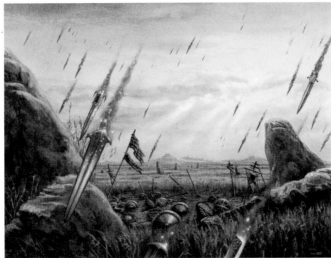

▲ RAIN OF BLADES
The side planes of the rocks are less strongly lit and are colored by the orange in the sky. The front planes are in shadow, influenced by the colors of the ground.

▼ ALABASTER JAVELIN
A shaft of light from above strikes the head of the javelin. The shadows are painted transparently, so that they recede and become a setting for the main focus of the painting.

Opaque paint is used only in the area of strongest illumination.

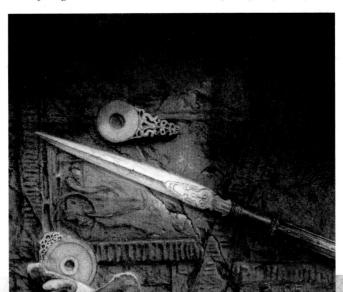

FIVE BASIC TRUTHS

1 The shapes of the shadows must describe the shape of the object.
2 Render the lights, simplify the shadows.
3 Paint the lights with consistency across the image.
4 Light has a color.
5 Lights are opaque; shadows are transparent.

SEE THE LIGHT

The benefits of squinting

If you are having difficulty seeing the values in your subject or painting, squint. This will eliminate superfluous details, allow you to mass objects and values readily, and enable you to see and compare values without the distraction of colors or textures.

Don't adjust the light!

As you work, particularly if you are working from life, learn to see the whole subject or image at once. Do not let your eyes linger on any one section for too long; otherwise, your eyes will adjust to the different light level in that area and you will start to paint all the new information you see. This will create different lighting conditions for the lights and shadows of your image, and destroy the masses you created earlier.

Tonal studies

Whether your tonal study takes the form of a detailed drawing before painting or an underpainting on your canvas which you will work directly over the top of, take the time to do this, and do it right (see p. 23).

LIGHT HAS A COLOR

Light does have a color, whether it's very subtle or strong and easy to discern. This color will obviously be most noticeable in the strongest highlights, where most of the information that reaches your eyes is the pure light being redirected. As the object recedes from you, or curves away, less and less of the primary light will be reflected toward your eyes, and the more influence the reflected and secondary lights will have. The result is that in the midtones you will see the actual or local color of the object most strongly, as well as the most color diversity from all the other light sources.

Shadows are the result of a solid object impeding the flow of light, and, therefore, they will show a decided lack of the color of the light and be most influenced by secondary light sources. Think of the light and shadows on a field of snow. Where the sunlight hits, it predominates, perhaps giving the snow a warm, yellowish look. In the shadows, where the main light does not reach, it is the cool blue of

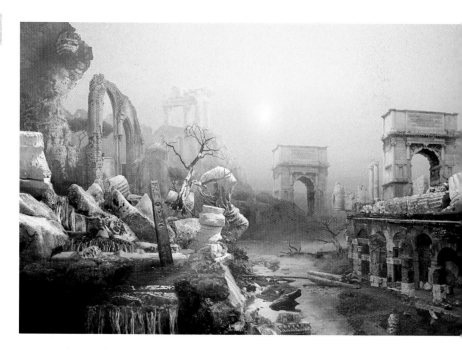

the sky above which determines the color. The sky is the secondary light source. Now, imagine that a person stands nearby, holding a torch with a green flame. Where the light from the torch hits, colors will shift toward the green of the torch. So, part of the snow will appear green, part of it blue, and part of it yellow, depending on where the light falls.

LIGHTS ARE OPAQUE, SHADOWS ARE TRANSPARENT

It is the illusion of real light striking your eyes that you as the artist are attempting to recreate. In order to best capture that, it is usually best to build up the lights with thicker, more opaque paint, often glazing pure colors over the area once it is dry. In this way the sense of bright, pure, clean light can best be reproduced. Shadows, by contrast, should be transparent. They should seem like something you can peer into, perhaps even get lost in, but never make out clearly.

Transparent watercolor would seem to be the exception to this rule, but it is not. The opaque white of the paper is the light for a watercolorist. The more paint you put into a light area, the less pure light you have in that area. Think of the paper as the light source, and then delicately paint in only what the light will actually reveal in the highlights and midtones, and you will

▲ NO-MAN'S-LAND
The soft purple light of the sun colors everything it touches. In the cast shadows of the foreground, notice that the color is that of the sky, rather than the warm purple of the sunlight.

have achieved the same effects as the oil or acrylic painter who uses opaque colors in his or her lights.

CLASSICAL LIGHTING

Classical lighting has been used since the time of the Old Masters to show the volume or three-dimensionality of an object, as it is the most descriptive and versatile way of lighting your subject.

This illusion of three-dimensionality is achieved by having the main light source strike the objects from about a 45° elevation, and 30° to the left or right of the artist, so that ⅓ of the object is highlighted, ⅓ is in shadow, and ⅓ is midtone.

Practice with simple, geometric shapes, and you will quickly see that everything in nature can be represented by one of these simple shapes, or a combination of them. Once you can create these shapes and combinations clearly in your mind, and understand how the lighting works on them, you will be able to understand and manipulate the lights in your paintings.

▼ CLASSICALLY LIT

This image examines the placement of lights and darks on an object in classical lighting. Try recreating the lighting in a painting of your own, or try adjusting the lighting in this example without losing the sense of volume and three-dimensionality.

POINTS TO KEEP IN MIND

- The wider the range of values, the more dynamic your piece will look. At the same time, the image will often have more strength and unity if you reduce the number of different values in it.
- Values, like colors, are relative to their context, and are affected by the values around them. If you need a light to look lighter, try darkening the values around it. Remember, the value of something that was correct for one painting may not be for another.
- Value is separate from intensity. Often the beginner artist will paint a very intense area of the painting with lighter values than it really has. The colors of fall leaves may be intense but the value of the reds and golds will still be a medium dark. It will just be a very intense medium dark.
- Crisp, well-defined edges in the light areas of a painting and softer or even lost edges in the shadows will strengthen the sense of three-dimensionality in your image. Also, the stronger the contrast between two objects or edges, the crisper the edges will appear. A dark tree branch seen against the sky will seem to have sharp, crisp edges, while the tree's roots against the dark grass will be less clearly defined.
- You must constantly balance and check your value relationships. As the painting progresses, you may find that values which once were correct now need to be lightened or darkened.
- An easy way to check the balance of your light in an image is with a black glass. Take a handheld mirror and paint it black. When you look at the reflection of your image in it, all you will see are the light masses, allowing you to balance them easily.
- No amount of color work, detail, or rendering will make up for poorly realized values.

LIGHT SOURCES

Light direction can have a great effect on your images. Use the images below to practice using different light sources and directions in your work.

Lit from the left—the object casts a shadow and texture is well defined.

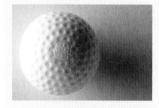

Seen from overhead—the surface of the object is divided into highlight, midtone, and shadow.

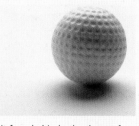

Lit from behind—the shape of the object is well defined, a shadow is cast forward.

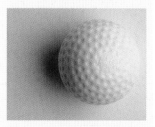

Lit from overhead and to the right—the object loses definition on the right.

COLOR THEORY

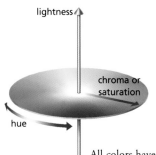

Ultimately, the use of color in your image is a personal choice, be it intuitive, methodical, or emotional. However, the qualities and characteristics of light and color must be understood if you are going to create the look and effects that you want.

All colors have four characteristics: hue, value, intensity, and temperature.

- Hue is the actual color itself, be it red, green, or chartreuse.
- Value is how light or dark your color is. It's what you would see if you took a black-and-white photo of your color.
- Intensity is how bright or dull the color is.
- Temperature is how warm or cool the color is.

There are two important things to keep in mind as you work with color.

First, remember that you are not painting an object—you are painting the effect of light on that object. Think of how differently a blue vase would look under a green light as opposed to under a red light. Light has the same four characteristics as color: hue, value, intensity, and temperature. As you paint, you must show the effect of these characteristics of light, or their absence, on the objects you paint in order for them to look three-dimensional. Since the qualities of the light on your objects will change, based on the objects' distance from the light source (as well as being influenced by secondary and reflected lights), you must address and modulate all four of the characteristics of light constantly as you paint.

Second, the characteristics and appearance of a color are not absolute, but are determined by the colors around it on your paper or canvas. Color is always context sensitive because the color you see on the paper or canvas is influenced strongly by the colors next to it. What appears to be a very warm red on the cool white of your palette will not look the same next to a very warm yellow or a very cool green in your painting.

You cannot change any one aspect of a color without affecting the other three, and all four characteristics must work together.

Understanding and capturing the constant, subtle changes caused by light, as well as those brought about by the other colors on your canvas, can quickly become overwhelming, which is why so many artists do a value study or an underpainting to work out value relationships, and perhaps another layer to work out the temperature relationships, before delving into the final colors.

PRIMARY AND SECONDARY COLORS, NEUTRAL COLOR

There are three primary colors—colors that cannot be created by mixing other colors together: red, blue, and yellow. Secondary colors are made by mixing any two of the primaries together—for example, red and yellow to make orange.

The complement (opposite) of any primary color is the other two primaries mixed together, and the

▼ COLOR WHEEL
Reds, yellows, and blues are the primary colors, colors that can't be mixed from other pigments. Any two primaries may be mixed together to create a secondary color, but only by careful observation and understanding of the nature of the colors can you create the secondary that is right for your needs.

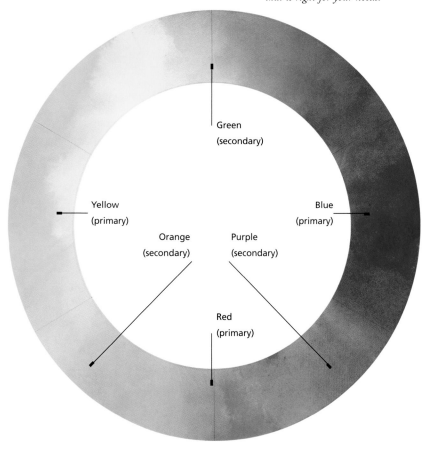

Green
(secondary)

Yellow
(primary)

Blue
(primary)

Orange
(secondary)

Purple
(secondary)

Red
(primary)

complement of any secondary color is the one primary color it doesn't contain. For example, the complement of red is blue plus yellow, or green. The complement of purple (red and blue mixed) is yellow.

You can mix any two primaries, in whatever proportion, and get a good result. Adding the third primary creates what is called a neutral. For example, you may mix a strong yellow and a small amount of red to make a yellowish orange. But if you add blue, it will fight the orange and dull or neutralize it. Done well, this dulling of colors produces some incredibly subtle color variations and neutrals, the foundation of any great painting. Done poorly, it will give you a canvas of muddy colors. A good rule of thumb: the more evenly balanced all three primaries are, the closer you will come to a muddy gray. Let one or two dominate, and keep the third as the counterpoint.

COLOR HARMONY AND CONTRAST

When colors with a similar temperature are mixed together they will have harmony—looking as if they are illuminated by a similar light source—and the mixed colors will look clean and bright. A warm reddish purple and a yellowish orange would seem to cancel each other out, but, in reality, both contain a lot of the same warm red, which ties them together. This is an example of creating a neutral with one primary (red) dominating.

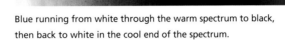

Blue running from white through the warm spectrum to black, then back to white in the cool end of the spectrum.

Red running from white through the warm spectrum to black, then back to white in the cool end of the spectrum.

Yellow running from white through the warm spectrum to black, then back to white in the cool end of the spectrum.

Second yellow, all in cools, showing a lack of temperature change.

▲ EVERYBODY MOVES AT ONCE
As a color's value changes, so does its temperature, intensity, and hue. Each color can be painted warm or cool, at any value, and can be dull or intense. Do not think of all blues as cool and all yellows as warm, any color can be warm or cool. Compare the two different yellow bars. In the second one, temperature has been left out. As a result, while the yellow does change its value, hue, and intensity, there is no sense that light of a certain temperature is illuminating some areas and not others, and so your object will not look properly three-dimensional, partially in light and partially in shadow.

▼ TEMPERATURE
If colors of different temperature ranges are mixed, they look dull and gray. This is most noticeable when a color and its complement are mixed.

warm red, cool green

▼ HARMONY
Harmony and contrast are vital in painting to create the colors found in nature. Dab colors next to each other to see how their appearance changes based on the colors around them.

warm orange, cool blue

cool yellow, warm blue

cool red, warm blue

cool red, cool blue

warm red, warm green

warm yellow, cool blue

warm red, cool blue

warm yellow, cool violet

warm yellow, warm violet

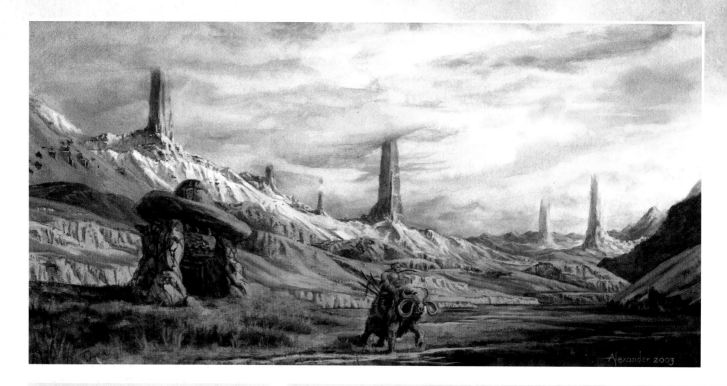

HOW DARK IS DARK?

b/w value strip

Need help with the values of your colors? Make yourself a value strip, blending from black to white. Hold this strip a comfortable distance from your eyes and squint past it to your subject to determine the value of a certain area.

value strip

Highlights are not white!

Make sure there is enough color in your highlights. Highlights are not white—they will always have some color in them. Your highlights will actually look brighter and stronger if you use a light compliment of the color of your light source, such as a green highlight for a red light.

highlights swatch

Muse on a break?

Not sure what color to make it? Colors are powerfully mood inducing. When you're stumped, try asking yourself what the mood of your painting is, and you may find that will answer the question for you.

mood swatch

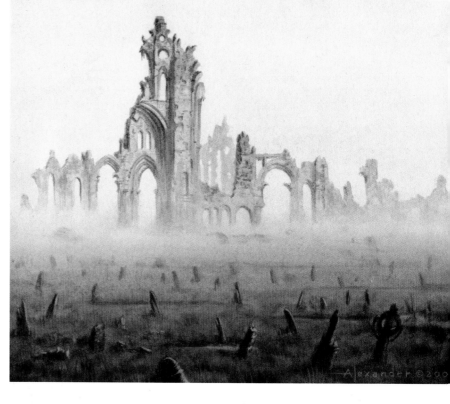

▲ ADVANCING AND RECEDING COLOR

Do not make the mistake of thinking that all cool colors recede and all warm colors advance. Colors that are intense, saturated, very light, or very dark will tend to advance, while colors that are less intense, less saturated, or a mid-range value will tend to recede. Mountain Plateau (top) has a warm foreground and cool background while Quiet Rest features a cool foreground and warm background.

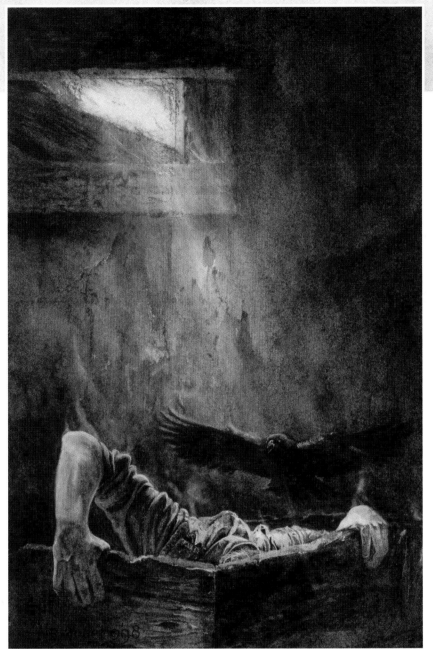

▲ BROKEN COLOR

Broken color is a thick layer(s) of paint applied over a layer of a different color in a patchy or broken manner. The layer underneath shows through the broken layer(s), and the result will be two or more distinct colors being perceived and mixed by the eye. These colors will appear much more vibrant than if they were mixed together on the palette or canvas. Here (left), broken color is used in the texture of the wooden walls.

▲ COLOR APPLICATION

The final appearance of a color in your painting is determined by three things: the specific color you mix; the colors surrounding it on your paper or canvas; and the way you apply the colors to your canvas. There are three basic methods of applying paint; all are employed in the painting above.

▶ OPAQUE COLOR

Opaque color is applied in a thick layer. Light cannot pass through the layer but bounces off the surface of it. Opaque paint may be uniform and flat in appearance, or subtle and varied, like an alla prima ("all at once") painting. In the main image (above) the artist has used opaque paint for the highlights on the figure's hand and back.

▲ GLAZING

A glaze is a layer of color applied thinly enough that it is transparent. Light passes through it to the colors underneath, which can still be seen but are affected by the glaze. The effect is similar to looking at something through a piece of stained glass. The colors you use and the order in which they are applied will determine your final color.

Glazing is often used to give dark shadows a luminous, liquid depth. Light passes through the glazes, bounces off the white paper or canvas, and comes back out, increasing the luminosity of the colors without lightening their value. Glazing has been used in the main image (top, left) in the shaft of light which passes the wall to the figure and in the shadows to create depth.

BASIC PERSPECTIVE

Things appear to get smaller the farther away they are. Linear perspective is simply a tool that will allow you to create a sense of distance and scale in your images, to show objects overlapping, getting smaller, or converging in an orderly and understandable way.

Perspective follows a number of rules; like all rules, they must be learned and understood thoroughly, so that you can break them with surety and confidence when you need to. Gradually, as you become more confident with perspective, you may well find that you begin to eyeball your perspective, perhaps plotting out a few key lines and estimating the rest. This will work only if you know the rules well enough to use them in your head.

Perspective is built upon rectangles and 90° angles. In all the examples, it should be understood that the structures drawn must either be built of 90° angles or placed inside an imaginary box which is.

ONE-POINT PERSPECTIVE

Front

Front

Front Front

A

▲ OVERVIEW
Imagine a scene as a bird might view it from overhead. You (A) and the "front" side of all the objects are parallel. All side planes recede towards a single point.

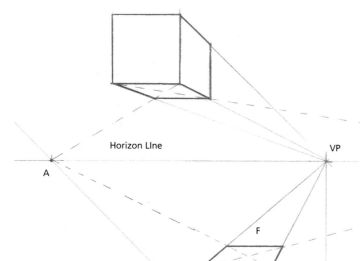

Horizon LIne VP

A B

F

D E

**▲ PLOTTING
A SQUARE OR CUBE**
From the vanishing point, mark off three points equidistant from each other—two on the horizon line (A and B), and the third straight down from the vanishing point (C). Point C is where you are viewing the object from, and the triangle ABC represents your cone of vision—the area you can see

C

without distortion. Draw the leading edge of your square or cube, and from each end of this line (D and E), extend the sides of your shape back to the vanishing point. Then, from each of the forward corners, draw a line to the opposing

point (A or B) on the horizon line. Where these lines cross the sides of your object, draw in the back edge (F). This will give you a perfect square in perspective.

To make the cube, simply add the vertical lines (the same length as your horizontal leading edge) to the leading edge, plot out the back edge of the plane facing the vanishing point, and it becomes the depth of your cube.

If you want a rectangle, rather than a square, you can simply place the back edge at any point you like.

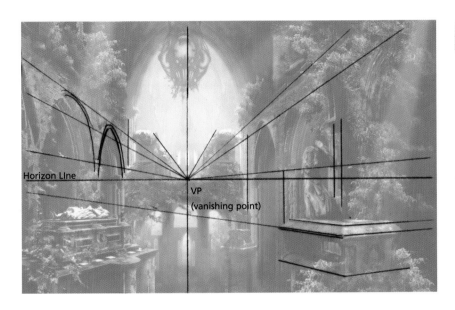

Horizon LIne

**VP
(vanishing point)**

▲ PUTTING IT INTO PRACTICE

A scene as the artist sees it. The walls and the arches converge on a single point. The entire scene need not be in one-point perspective. The shape in the lower right corner is in two-point perspective, but its vanishing points are on the same horizon line, so it reads correctly. Remember to keep all your vertical lines vertical, or your buildings will begin to lean.

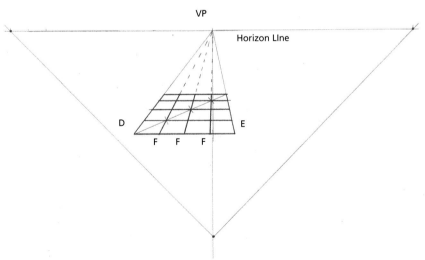

VP

Horizon LIne

D E

F F F

▲ DIVIDING A PLANE INTO A GRID

Create a triangle as on page 38 opposite and draw your plane. Along the leading edge (D/E), mark off the number of units you need (F), and extend each one to the vanishing point. Then, draw a line from a front corner to the opposing back corner. The points where this line crosses the lines from F to the vanishing point are your horizontal dividers.

COMMON DEFINITIONS

Horizon or eye line

This line represents the height from which you are viewing the object or scene. Outdoors, this will actually be the horizon; indoors, it will be a horizontal line which represents your eye level. The only exception to this would be if you were outside viewing something from a very high or wide vantage point, in which case the slight curve of the Earth would be noticeable.

Vanishing point (VP)

This is a point on the horizon line at which parallel lines of an object seem to converge. There may be only a single vanishing point, or there may be multiple ones. These points are not fixed, but are determined by what you are seeing and where you are seeing it from.

One-point perspective

This occurs when you and one side of the objects you see are on parallel planes. There will be a single vanishing point, so it is called one-point perspective. Think of the way a road, a row of power poles, and a fence often all seem to converge at a single point on the horizon.

Two-point perspective

This occurs when the objects you see are at an angle to you. There will be one edge or corner that is closest, called the leading edge. Both sides of the structure which recede from this leading edge will have their own vanishing points; hence the term two-point perspective.

Three-point perspective

This is very similar to two-point perspective but with the addition of a third vanishing point located either above or below the horizon line at which all the vertical lines converge. Three-point perspective is most often used when depicting tall buildings or very wide panoramas.

Vanishing trace

This is a point directly above or below a vanishing point. Vanishing trace is used to determine the correct angles on things like sloping roofs, as well as to determine how to keep the distances between a row of objects uniform as they recede, such as a row of telephone poles.

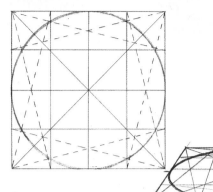

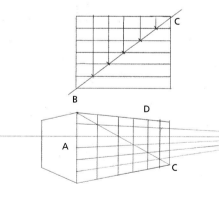

TWO-POINT PERSPECTIVE

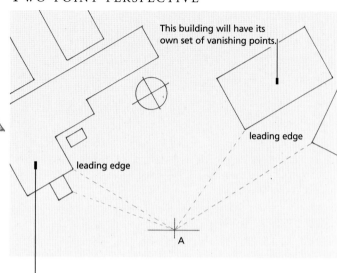

This building will have its own set of vanishing points.

leading edge

leading edge

A

These buildings are all parallel and so will all share one set of vanishing points.

▲ ELLIPSES

An ellipse is really a circle in perspective. While you will often have to draw your ellipses freehand, you can give yourself a few guides to help out. The flat square shows the points at which the circle and square connect. Simply draw the square in perspective, then freehand draw the ellipse, using the points of contact as your guide. Note that the widest part of the ellipse is not the mathematical center of your square but slightly in front of it, as you are not looking at a flat ellipse but at a circle in perspective.

▲ OVERVIEW

Once again, imagine the scene from a bird's point of view. Any object that is at an angle to you (A) will be in two-point perspective. Note that objects that are parallel, such as the structures on the left, will all share one set of vanishing points. Each of the other structures will have its own vanishing points, as they are each at a different angle. The leading edge is the closest corner to you.

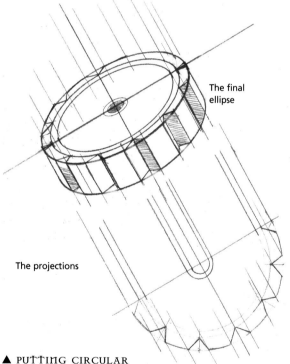

The final ellipse

The projections

▲ PUTTING CIRCULAR OBJECTS INTO PERSPECTIVE

How do you determine where the details will go on an ellipse? Simple. With an artist's compass, draw a half circle, or blueprint, the same width as your ellipse, on the same axis (angle). Draw in the details on your blueprint. They can be symmetrical, like the example, or randomly spaced (although if your details are random, you will need to draw the whole blueprint and all the details). Now you can simply extend the lines from your blueprint to your ellipse to determine the placements of all the details.

▲ DIVIDING A PLANE INTO EQUAL UNITS

Just as in one-point perspective, you can divide your shape into any number of units along the vertical leading edge (A) and extend these points to the vanishing point. A diagonal from corner to corner of the shape (B/C) crosses these lines and indicates where the vertical lines must be (D).

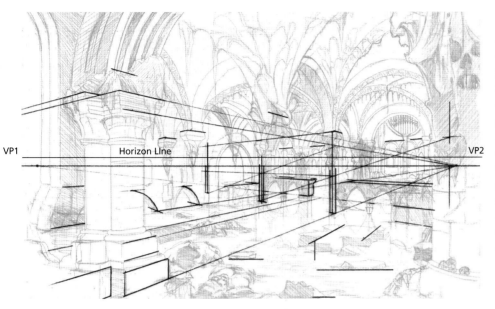

VP1 Horizon LIne VP2

◀ PUTTING IT INTO PRACTICE

In this interior the structures are parellel to each other. Draw in the horizon line where you want it, and freehand draw some of the key elements. Extend the lines of these elements to the horizon line to find the vanishing points, and from there, you can build your room. Note how the heights of pillars, arches, and hanging shapes are kept constant by drawing the one in the foreground, then projecting its height to the vanishing points to determine the heights of the others. You may find that your vanishing point is well off the edge of your paper. Mount your drawing to a large drafting table or long board so that you can extend the horizon line by several feet if need be.

▼ THE END RESULT

What at first seems extremely complex becomes simple with perspective. Even the rubble on the floor is easy to place once you have the vanishing points.

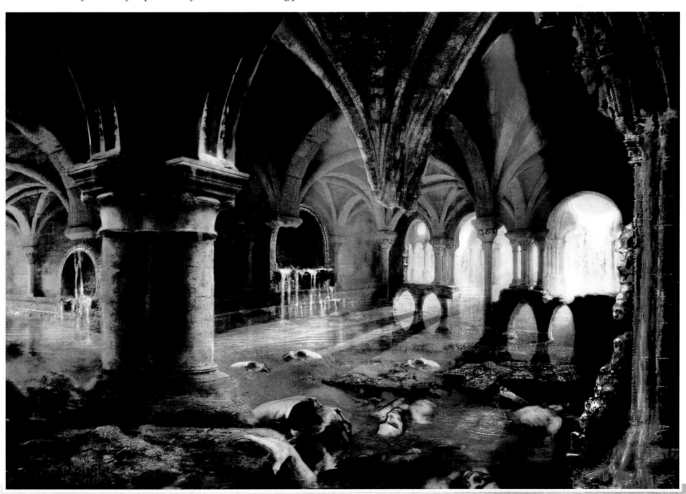

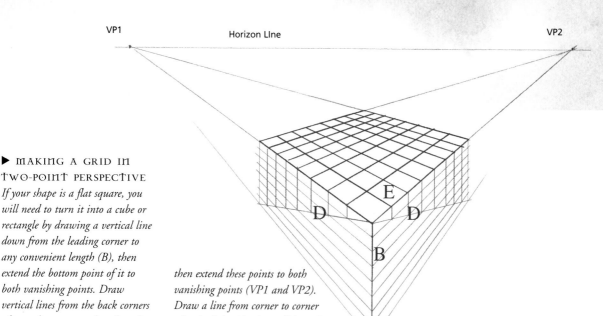

VP1 Horizon LIne VP2

E

D D

B

▶ MAKING A GRID IN TWO-POINT PERSPECTIVE

If your shape is a flat square, you will need to turn it into a cube or rectangle by drawing a vertical line down from the leading corner to any convenient length (B), then extend the bottom point of it to both vanishing points. Draw vertical lines from the back corners of your shape to complete the cube. Then divide the front vertical into the number of lengths you need (B). If your shape is already a cube, simply divide the leading edge into the number of lengths you need;

then extend these points to both vanishing points (VP1 and VP2). Draw a line from corner to corner of each of the side planes (D), and extend the points where your lines cross vertically to the edge of your upper plane (E). Lastly, extend these points to their opposite vanishing points to create your grid.

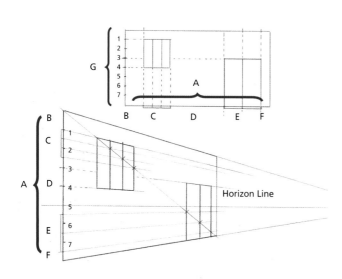

G { 1 2 3 4 5 6 7

A

B C D E F

B
C

A { 1 2 3 4 5 6 7 Horizon Line

D

E

F

▲ PLOTTING UNEQUAL DIVISIONS

What do you do if you cannot divide your shape into equal lengths? Simply enlarge or reduce your original flat plan of the shape until the length of it is the same as the height of your shape in perspective (A). Measure the various lengths along the plan (B, C, D, E, and F), and mark these same points on the leading edge of your shape in perspective (A), starting at either the top or bottom. Extend these marks to the vanishing point. Once again, draw a diagonal line from corner to corner (you must start at the top corner if you marked off B–F beginning at the top of A, and from the bottom front corner if your marks started at the bottom of A) to find the vertical placements. To determine the heights of your areas, simply divide the vertical of your plan (G) into lengths, mark off the ones you need along the leading edge of your rectangle in perspective, and extend them to the vanishing points.

VT

Horizon Line

VP

B A

Y

D

X

▲ DIMINUTION

Diminution means the regular spacing of objects in a row, such as telephone poles. It works the same in one- or two-point perspective, horizontally or vertically. You will need to determine the height of the objects, and their spacing.

Height (or width) is determined by extending a line from the top and bottom (or edges) of your object to the vanishing point. This will give you the height at any point between yourself and the horizon line, and from there, you can slide the shapes horizontally and they will be in perspective, such as posts X and Y. This is also the way to determine the height and placement of people in your drawing.

Uniform spacing can be determined one of two ways:
1 Draw in the first two objects by eye, such as posts A and B. Find

the midpoint of pole A, and extend a line from it to the vanishing point (VP). Now, draw a diagonal line (D) from either corner of post A through the midpoint of post B. Where line D crosses the height line is the placement for the next post.
2 If you wish, you can also extend line D until it reaches a point directly above or below the vanishing point, called the vanishing trace. (This will work the same way in two-point perspective.) Each diagonal line from one corner of the post through the midpoint of the next post will converge at this vanishing trace.

You can also slide objects vertically once you have determined their height, such as the poles marching over the hill, and they will still read as being uniformly spaced.

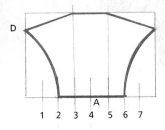

▲▼ PROJECTING ODD SHAPES INTO PERSPECTIVE

Any shape can be enclosed within a rectangle. Simply draw a box around your shape and divide it into even lengths corresponding to the vertical landmarks for your object (A). Divide the leading edge of your rectangle in perspective into the same number of lengths (B) and extend these points to the vanishing point. Draw in the

diagonal to find the vertical markers (C). You now have the landmarks you need to help you draw your odd shape in the perspective you have chosen. If you need landmarks for the height of your odd shape, such as the outer edge at (D), divide the vertical edge of your drawing as you did in (A), above, and divide the leading edge of your rectangle in perspective into the same number of lengths, then extend the marks (D) to the vanishing point.

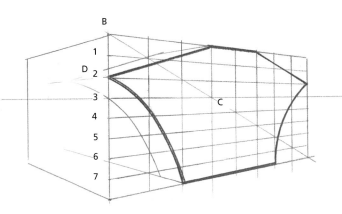

THREE-POINT PERSPECTIVE
▼ SKYSCRAPERS

Three-point perspective works just like two-point perspective, except for the addition of a third point located well above or below the horizon line. Often, it is best to have all your structures share the same three vanishing points, and spread your points out quite a way, or the extreme distortion will look forced and unreal.

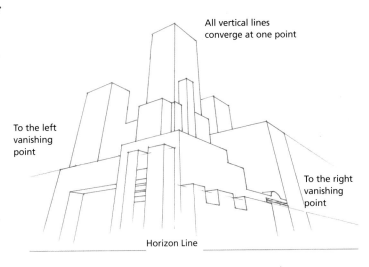

All vertical lines converge at one point

To the left vanishing point

To the right vanishing point

Horizon Line

▼ WATER WAYS

Using three-point perspective, the artist has created a sense of hovering above a vast city, but also created breaks in the building shapes, directing the eye and creating rhythm and flow.

TOOLS OF THE TRADE

There are a few tools you will need in order to work out your perspective. Learn to use them, and they will save you hours of frustration. Take care of them and they will last a lifetime.

T-Square—long metal ruler with a T-shaped head at one end.
Set Square—triangular rulers. The most common are 45°/ 90° and 30°/ 60°/ 90°.
French Curves—a set of curve templates.
Artist's Compass—for circles, of course.

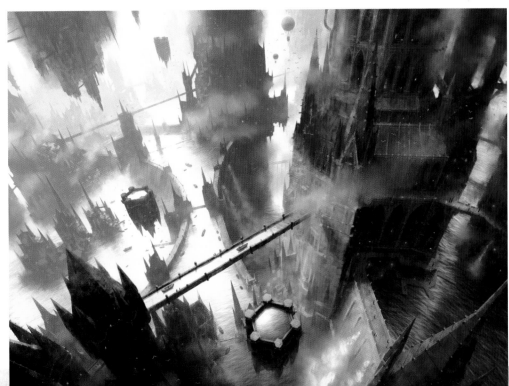

ARCHITECTURAL DETAILS

At some point, if you choose to paint fantasy or science fiction landscapes, you are going to be painting architecture. Often, this will involve some variation of historical architecture for the fantasy artist, and a high-tech, futuristic building for the science fiction artist.

Learn to study and appreciate all the various forms and styles of architecture; take photos when you travel, and ask your friends for copies of their photos. Study the paintings of the Old Masters, and focus on the large, broad shapes and forms of the buildings, and also on the details. Often, the difference between an image which looks poor or amateurish and one which looks professional is in the understanding of details such as window sills, statues, the textures of stones or roof tiles— all the things that differentiate one architectural style from another.

Clean lines, large shapes, the suggestion of details, and a strong sense of mass create an interesting futuristic cityscape.

All arches radiate from a fixed point or points; the cuts between the stonework point toward these fixed points.

Careful study of architectural details will help you in three important ways. First, it will allow you to personalize your artwork with the details that you want, handled in a convincing way. Second, as it's often the details that differentiate one style from another, you will be able to understand what makes Tudor style what it is, and not a Baroque, Gothic, or any other style. Last, by the time you have become thoroughly familiar with a wide range of details, you will also have learned enough about general architectural styles to become comfortable inventing your own structures or mixing styles, and will have acquired an ability to do so with confidence.

Old world architectural details combine with modern touches to create a convincingly timeless back alley.

◀ STREET
The watercolor washes and ink lines create a street with old, weathered buildings, full of character and history. Clearly defined shadows give a sense of structure and strength to the buildings, telling you that they have stood for centuries.

A series of round arches—alternating light and shadow gives a sense of distance.

Gothic arches are always pointed—use cast shadows to describe their deep shapes.

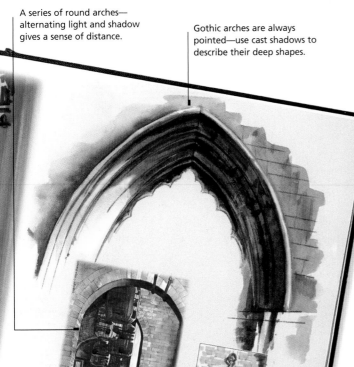

On these pages are several examples of architectural details. This is by no means a comprehensive showcase but rather a broad introduction to help you to kick start your imagination and come up with your own designs. Remember, if your buildings look solid, real, and convincing, you will have tremendous scope to create something very unreal, that looks as if it could exist. The laws of physics may tell you that you will never see a 1,000-foot high, flying Gothic cathedral, or a mile-high skyscraper. But fantasy art has no such restrictions. As an artist, you can rely on the visual familiarity of something to convince viewers of your vision and make them believe it could be real. If they recognize the cathedral or skyscraper as being similar to ones they have seen in their own life, that familiarity will allow you to create the 1,000-foot cathedral in all its glory, and viewers will believe what you tell them about it.

◄ STRONG STRUCTURE

Architecture must have a sense of structure—the lighting and shadows must clearly describe the shapes and make them look solid and sturdy, whether they have the clean lines of a new building, or the rough edges of ancient ruins.

▼ PERSONAL TOUCH

Steps, doorways, roof tiles, and columns all have variety and flexibility in their designs, which allows you to create exactly the look you want in your paintings.

Doorways can be full of interesting details, like this one with an alcove for a statuette or figure.

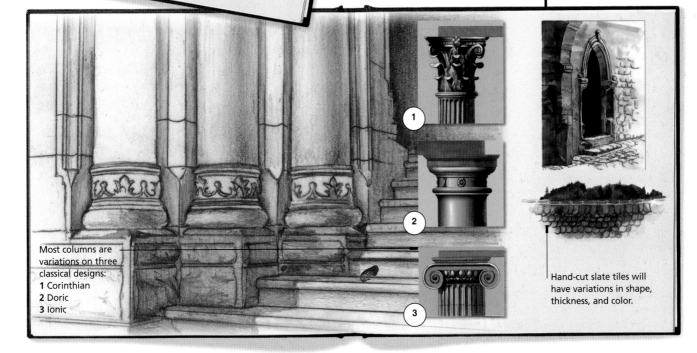

Most columns are variations on three classical designs:
1 Corinthian
2 Doric
3 Ionic

Hand-cut slate tiles will have variations in shape, thickness, and color.

DISTANCE, DEPTH, AND SCALE

Distance, depth, and scale are about creating the illusion of three-dimensionality on a two-dimensional surface. Use the tools available to you to convince the viewer that the objects in your image exist in space.

Achieving depth requires a careful observation and understanding of color, value, and contrast, proper manipulation of perspective, and, mainly, a knowledge of how light and air influence what we see. Some of the most common solutions for creating depth in an image are the overlapping of forms, perspective lines, and the diminution of forms—having them shrink as they recede, such as a row of trees or the buildings on a street.

However, these solutions alone are not enough. Were you to use a photocopier to reproduce a section of your painting and then place the reprduced images one behind the other, your eyes would tell you that the images overlap. Therefore, one must be in front of the other, but your eyes would also tell you that the depth created was very shallow, that something is missing.

ATMOSPHERIC PERSPECTIVE

A true sense of depth starts with air and light—what is commonly called aerial or atmospheric perspective. It is light, passing through all the air between you and your subject, that has the biggest influence on what you see or don't see. Distant objects will have less contrast, more subdued colors, fewer details, less texture, and will shift very noticeably toward the colors of the air around them. Often, in an outdoor scene, as the distance is the horizon, this means the color of the air will be a light to medium blue, but the process is the same for a yellow sunset, the reds or greens of an alien planet, or any other setting. (It is the lack of this softening due to air that makes a scene in space or on an airless world look as it should.)

Remember, the highlight is the first thing to drop out or disappear as the objects recede, and then the shadows, until you are left with only a midtone suggestion of the form. Also, thinner parts of the form will become more difficult to discern, such as

As the mountains recede, they take on the colors and values of the sky and become large, simple masses.

the branches of a tree, before the thicker parts of the form, such as the tree trunk.

Be aware that the edges of something become increasingly blurred as it gets further away from you. Therefore, if you need to be able to clearly see the edges of something in order to be able to identify it, the form will become increasingly vague as it recedes.

Think of a person walking away across a field. At first, it will become hard to see features and recognize the person, and he or she will become a bulk moving away from you. Then, head, arms, and legs will become hard to make out, in that order. Finally, the person will simply be a blob moving across the field.

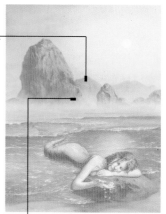

First to drop out are the lights, then the darks. Heavier, moister air near the horizon obscures the bottom of the mountains.

EFFECTS DUE TO CHANGES IN THE AIR

Open any art history book and look at the landscapes of some northern European painters, such as the Dutch, and then at French or Italian painters, and finally find something from an artist's trip to the tropics. You will immediately notice that the Dutch paintings are cooler, with colors more in the blue range, that the light looks weaker, but that you can see a long distance. In the French or Italian works, the light will be a bit warmer, the colors may well look richer, but you will not be able to see as many details in the backgrounds of these pieces. An image from the tropics will be warmer still, with the light stronger, but you can almost feel the moisture in the air, lending a softness to the whole scene and flattening it relative to the northern works.

Temperature, altitude, time of day, and humidity all affect what you see and how much air you are looking through. Primarily, it is the water and particles in the air that have the biggest effect on what you see. The less water and particles in the air, the less noticeable the effect will be. Mountain air is often referred to as crisp, clean, and clear, and so it is, relative to the heavier, moister air of lower altitudes.

All of this will help you to paint something and make it look as if it is a long way away, but how does the air affect the foreground elements?

The answer is that they are affected in exactly the same way, just to a lesser degree. In fact, the best way to get that tree trunk in the foreground to seem rounded, and to be a part of the same picture as the distant hills behind it, is to introduce some of the color of the air into the halftones where the tree curves away.

The light and air are the most powerful, most pervasive unifying elements to your picture. They are around and between everything in your painting, and everything you see is viewed through them. Your background color is not an arbitrary color that just appears there; it is a filter through which the entire scene is viewed.

The greenish color of the air quickly swallows up the background, giving the scene a heavy, moist feel, and reducing the distant trees to large simple shapes.

Cleaner colors and darker values are only visible in the foreground elements.

The strongest highlights are only visible in the immediate foreground.

THE COLOR OF DISTANCE

Having trouble getting the colors just right in order to make something recede correctly? Set your easel up outside, near a row of trees, power poles, or any other objects of similar color to each other, and paint on a sheet of glass in order to be able to instantly and accurately compare the colors you are painting with against nature. Hey, it worked for da Vinci!

MOOD AND DRAMA

Mood and drama are the emotional aspects of your drawing or painting. They are not new tools unto themselves, but rather, they arise out of how you handle things like perspective, lighting, and composition.

Whether you are using an early morning mist to obscure parts of an image and focus on others (composition), or a strong, dramatic light to create something epic, these are the elements or qualities of the image that will tell the story and engage the viewer.

Think of them as the realm where "I know exactly what I am seeing" ends and the realms of imagination, speculation, and intrigue begin, as a way to involve the viewer and to connect the viewer to the picture in an immediate and visceral way, so that the viewer's feelings, reactions, and imagination become a part of what he or she is seeing.

THE ARTIST'S ROLE

It is vitally important to become an impartial observer in order to truly understand what you are seeing, to take the information in. However, once you are ready to take that knowledge and let it out onto the page or canvas, it is critical that you not be impartial. The role of the artist should not be as an impartial painter. You are not simply copying nature or your reference, you must also be supplying an emotional content to your work. If something of yourself does not come across in your work, you have only painted a part of the picture, and missed out on the most important part.

On this page are several examples exploring the ways in which mood and drama can be created within a painting. Use these examples as a launch pad for your own imagination. There are as many ways to convey the emotional side of your work as there are emotions to convey. Just as a person may express multiple feelings, so too can a landscape. Look for them in the world, study them, and make use of them in your art.

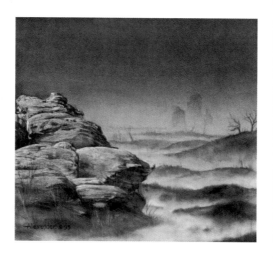

▲ OBSCURING AND SUGGESTING
Getting only a suggestion of what the forms are in the distant and rolling field of mist, forces the viewer to imagine what cannot be seen. This makes the viewer an integral part of what he or she is seeing, not simply an observer, and so what the viewer imagines will have meaning and allow a connection with the image.

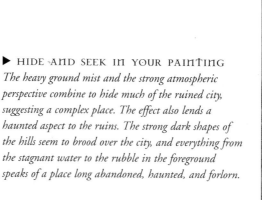

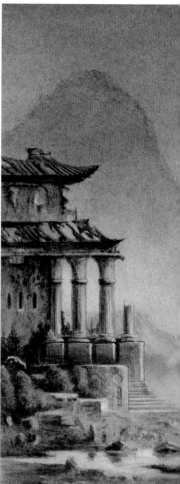

▶ HIDE AND SEEK IN YOUR PAINTING
The heavy ground mist and the strong atmospheric perspective combine to hide much of the ruined city, suggesting a complex place. The effect also lends a haunted aspect to the ruins. The strong dark shapes of the hills seem to brood over the city, and everything from the stagnant water to the rubble in the foreground speaks of a place long abandoned, haunted, and forlorn.

◀ MOOD THROUGH CONTRASTING LIGHT AND SHADOWS

A dark palette and a choice to have the light strike only the bottom of the cliff face allowed the cliffs to rise out of the mist and carry the eyes up and into shadows. The lower section, with the hint of a plateau that might be crossed becomes mysterious and inviting, urging the viewer to explore it, while the upper section takes on a much darker, contrasting feel, evoking that sense of danger and the need to stay away.

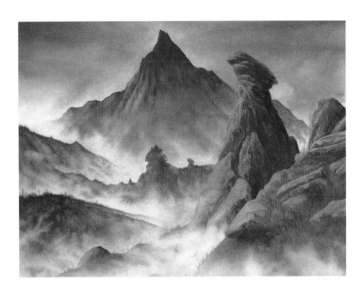

▲ CAST SHADOWS TO CREATE DRAMA

The gray, brooding sky and the shadow over the upper half of the mountain evoke the sense of foreboding and trepidation that the scene called for. It does not look entirely evil, but rather dark, depressing, and uninviting.

▼ DARKNESS AND MYSTERIES

The darkness forces the viewer to imagine what might be in the rest of the chamber. The more details you put in, the less room there is for the viewer's imagination to work in, and the less effective the piece would be. The trick lies in giving the viewer just enough to get started, at which point it's time to stop painting and let the picture carry itself.

SEASONAL VARIATIONS

Each season evokes a strong emotional reaction in viewer and artist alike. Learn to use these moods and emotional responses to generate or counterpoint the mood of your image.

The cool, dull gray of a late fall dawn can set the stage for a very melancholy painting, or it may provide a subtle counterpoint to the vivid color of a late season flower in bloom. Be aware of the additional impact and strength that your paintings can have, simply by changing the season. Remember, everything in your image is chosen by you, and all the elements—from the design to the handling of the paint, and from the colors to the seasons—have to work together in support of what you are trying to say with your image.

On these pages are several examples and studies that make use of the seasons to strengthen or establish the mood of the piece. Examine the effects of the choice of season upon the image, and ask yourself if the message of your own image would be strengthened by a change of season.

▲ SUMMER

The still waters, rich colors, and soft lighting combine to create a gentle image which evokes feelings of peacefulness and solitude. The open waters meander across the foreground, and draw the viewer into the scene.

Repetition of the sky colors in the water and rocks unifies the painting.

Reduced contrast keeps the background elements distant.

The strong contrast of the lighting is softened by the golden color of the light, eliminating any harshness.

The rocks become almost monochromatic, allowing the rich colors of the foliage to look even stronger.

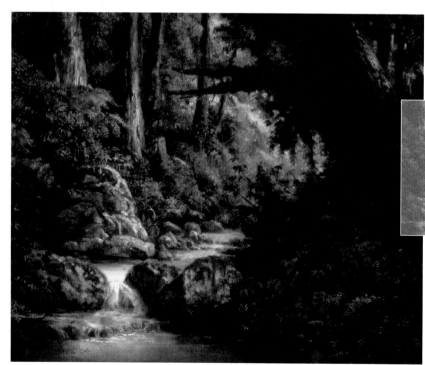

◀ SPRING

Tight cropping creates an intimate feeling, placing the viewer in the heart of the image—a sense strengthened by casting the right half of the image into shadow, so that the stream and foliage seem that much closer.

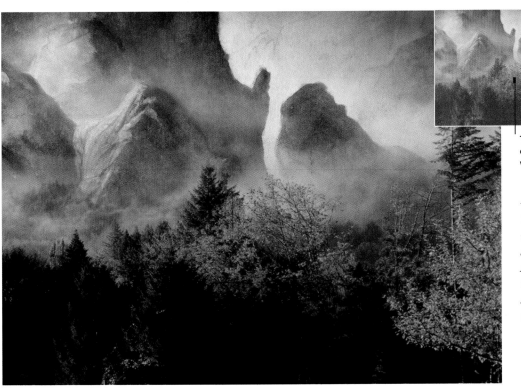

The movement and direction of the waterfalls and cliffs leads the eye right back into the foliage.

The strong, deep, cool greens of the conifers accent and strengthen the warm fall colors.

◀ FALL

The cool grays of the rocks set off the warm colors of the foliage, creating drama and visual excitement. Although the colors of the foliage range from yellows to reds, the strongest impression needs to be of warm colors.

▶ WINTER

Clean, bright colors, strong contrast, and cool lighting give a sense of cold, crisp air and clarity that is a key element to winter. Foreground elements have such a high contrast that you can increase the contrast in the mid-ground and background elements without sacrificing the depth in your image.

The sky will establish your palette and also the color, nature, and intensity of your lighting.

The mountains must relate to the colors of the sky, whether they contrast with them or reflect them.

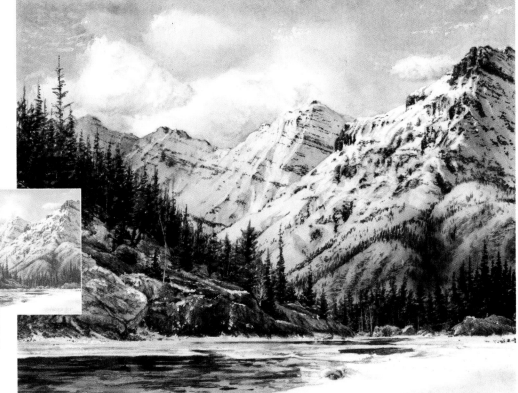

WEATHER AND TIME OF DAY

Just as the seasons evoke strong feelings, so too can the time of day and the weather. Allow them to become another tool at your disposal to help you create the feeling and mood that you need in your painting.

Imagine your image as a giant stage or movie set, but one in which you can control not only where everything is placed and where the scene will be viewed from, but also the direction, number, and nature of the lights, the weather, the time of day, and the season. Strive to see clearly in your mind what will best suit the image and convey your ideas, then set about to bring that all together the way a director would, so that the viewer is guided and directed by your vision, and so that the whole image works toward a single, unified statement.

On these pages notice how the overall mood and effect of the images changes significantly as the lighting, the shadow shapes, the temperature, the time of day, and the atmosphere all change. Just as some scenes in a movie will only work as night shots or sunrise shots, so it is with your artwork. Learn to choose the right time and weather for your needs.

▼ NIGHT
The light will be cool white, so shadows will look warmer by comparison. The ability of our eyes to differentiate color is greatly reduced at night, so keep the palette limited. Because the light source is the moon, the lighting is less intense. The result is a scene with strong highlights, deep dark shadows, and very few midtones.

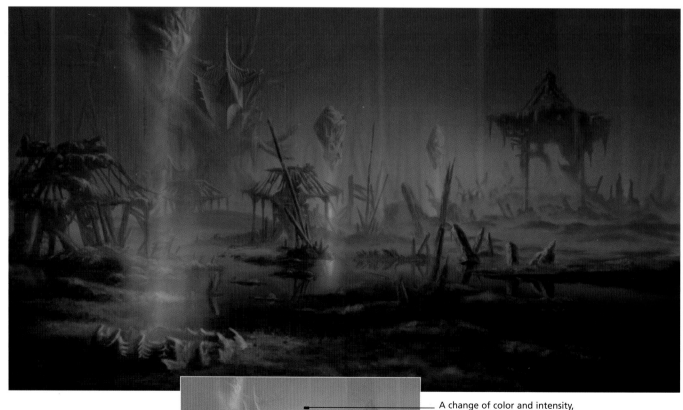

Warm, unearthly purple lights contrast with the cool palette of the rest of the painting, bringing the foreground grass closer.

A change of color and intensity, rather than value, provides drama and atmosphere without destroying the dark palette and the sense of night.

The deepest shadows are dark but not black, making them look darker and richer than if they were black.

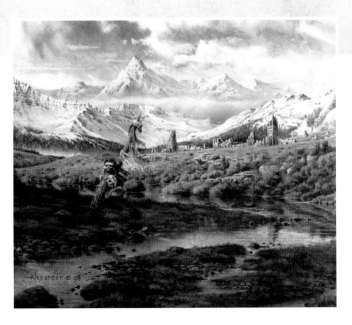

Cast shadows are lit by the reflected light from overhead. They have a cool sense to them.

The deepest darks will often appear to have a warmth to them.

▲ AFTERNOON

Afternoon lighting shows the elements in your painting most clearly but makes it harder to create mood or drama. Cast shadows tend toward the cool blue of the sky, while light areas tend toward the yellow of the sun.

▼ SNOWFALL

Snowflakes have soft, indistinct edges. The larger the flakes, the more pronounced the softness will be. Hard edges suggest sleet, rain, or ice. Remember to vary the size and opacity of your snow to create a sense of depth.

SUNRISE OR SUNSET

Remember that at sunrise the earth has been wrapped in the cool dark of night for hours. The air and ground have cooled, so that as light breaks over the horizon, it is coming through that cool air, and will look cooler as a result. The shadows will tend more toward blues and purples, and less to the warm reds or browns. The dominant light sense of a sunrise painting is the cool end of the spectrum.

At sunset, the air and earth have been warmed by the sun all day. The light will seem warmer and brighter, and the shadows will retain a strong hint of that warmth. The overall color effect will lean toward the warm end of the spectrum. It is at sunset that you will sometimes observe that curious lighting effect, which makes the world look as if you are viewing it through an orange filter.

Sunrise: Blues and purples in the shadows create a sense of coolness.

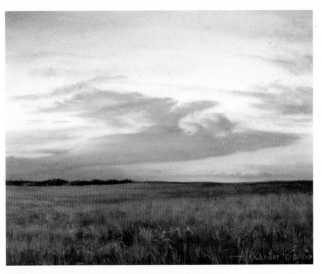

Sunset: The light seems warm and bright. Reds and browns in the shadows give a sense of warmth.

WEATHER VARIATIONS

Understanding and painting weather variations should be foremost in the mind of any landscape painter. Unless the world you are painting exists in a Hollywood sound stage, weather will be a constant, ever changing element. Weather provides some of the most dramatic, powerful opportunities for the landscape artist. Its impact on both the planet and our own psyche are immense, and this impact can be used to create mood and drama in your paintings, to spark a strong emotion in the viewer, and to bring your painting to life in a way few other things can.

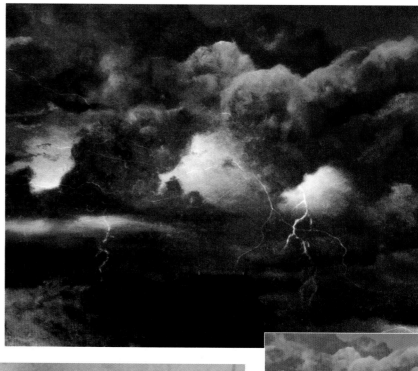

▼ FOG

Fog is water vapor at ground level. It will flatten your image and separate the elements into groups. The result is similar to viewing a series of stage backdrops, one in front of another. Suggest details, rather than rendering them.

| The complementary color of the lightning deepens the cloud shadows, making the lightning look brighter.

▲ LIGHTNING

Lightning will affect the clouds and atmosphere around it, often illuminating the clouds from the inside dramatically. The main shaft will be the brightest, the "branches" will be much less bright, and have soft, diffuse edges.

A branch in the foreground gives the viewer the information needed to make sense of the suggested details in the background.

A suggestion of darker trunks is all that's needed to convey a group of trees in the distance.

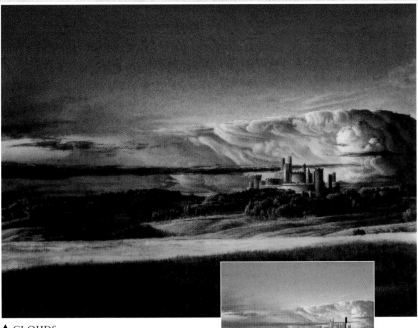

▲ CLOUDS

The time of day, and the angle and nature of the light, can be manipulated to produce drastically different results. Compare the image of clouds above with the one below to see how different lighting can create very different moods.

The dark, ominous clouds seem about to engulf the castle, giving the painting a strong sense of impending doom.

▼ RAIN

From a distance, rainfall looks like a series of "curtains," soft edged and indistinct. Rain seldom falls straight down. It is often pushed slightly by the wind into the familiar arcing shape.

Allow some background sky or cloud to show through the leading edge to give the sheets of rain a sense of transparency.

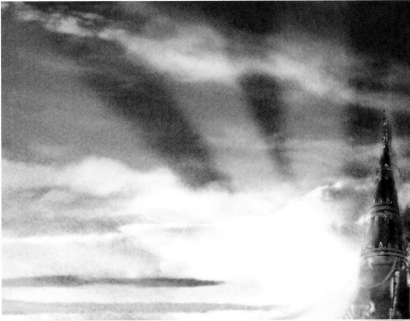

▲ SUNLIGHT BREAKING THROUGH CLOUDS

Light beams can break dramatically from behind clouds in any direction, not just downward, and are not opaque. The next time you are at a movie theater look across the theater through the light beam from the projector and study how much of the far wall you can see through it.

Soft colors and the low angle of the light create a romantic mood, making the clouds beautiful.

Allow some structures and objects behind the light beam to show through to avoid the light looking like a solid object.

Small horizontal clouds viewed against the brightness behind them will often appear quite dark, and can be a very effective way to set off the sunlight and make it appear brighter.

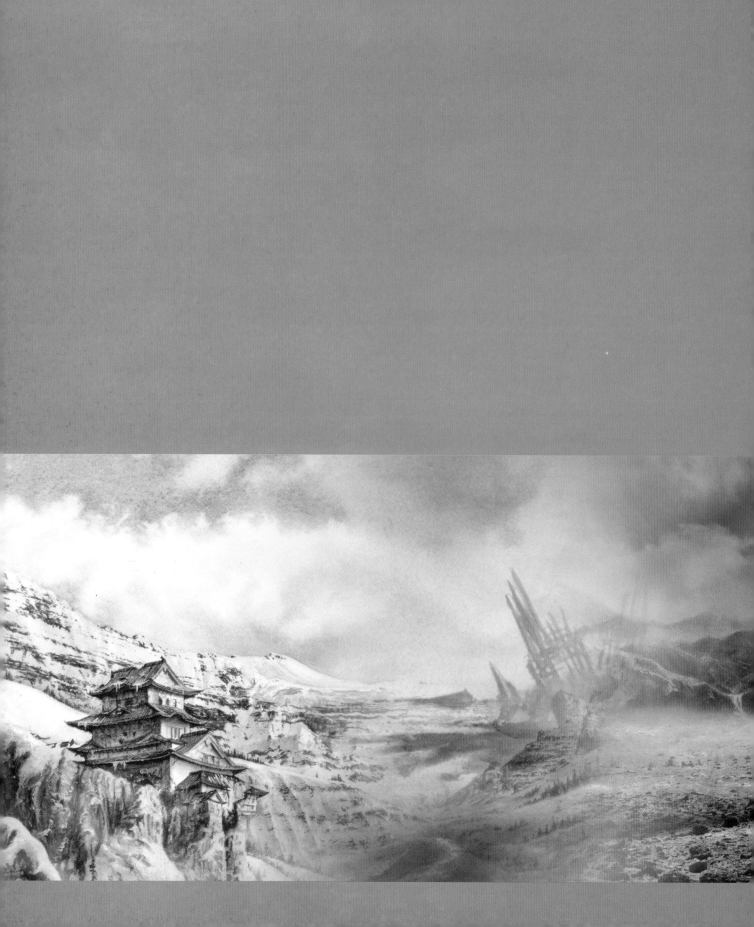

CHAPTER 2

ELEMENTS OF LANDSCAPE

Elements of Landscape shows you how to begin putting into practice what you have learned. All the major elements of landscape are shown, with studies and notes exploring the specific qualities of those elements. The rules and principles discussed in Basics of Art are explored more fully, and put into practice by creating small studies that will allow you to begin to draw and paint your own landscapes and cityscapes.

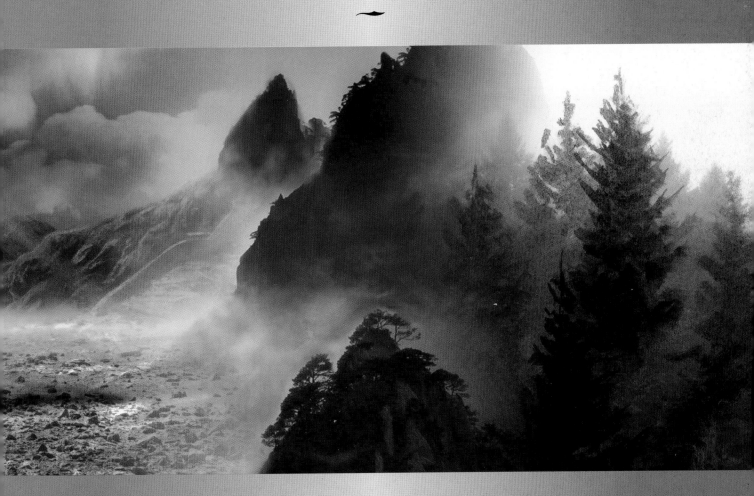

SKIES AND CLOUDS

Far from being merely a backdrop to the important elements of your image, skies and clouds are an integral part of the whole. Skies establish not only the palette of much of your painting, but also the nature and intensity of the light, the time of day, and the overall mood and drama of your image.

Clouds can either play the role of supporting actor, setting off the main elements of the painting and adding realism to the scene, or be the focus of the piece. Either way, they need to be painted with a strong sense of light, structure, and shape. In spite of their constantly changing nature, most clouds have a regular structure and pattern, and the more dramatic and imposing they are—such as a massing thunderhead cloud—the more pronounced the structure will be.

COLORS AND DEPTH

Clouds reveal the color of your primary light source, while the sky will dictate the color of the secondary light source. Colors from the ground plane will be reflected off the bottom of your clouds, and often the forms in the sky will merge with those on the ground near the horizon. This, combined with the sense of depth and distance that skies often create, will provide you with a strong tool to establish a sense of depth and space in your ground plane elements.

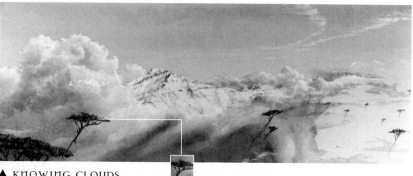

▲ KNOWING CLOUDS
Once you are familiar and comfortable with the different forms and elements of clouds and skies, even strange, whimsical compositions become very easy to create. Knowing how to give your clouds structure, movement, and rhythm allows you to combine elements that may never be found together in nature, and make them look natural.

DIRECTION
The trees, the high wispy clouds, and the end of the large cloud bank all move to the right in the wind, giving unity and cohesiveness to otherwise disparate elements.

TIPS

- Think harmony. Use the sky colors in the reflected lights of the ground, and the ground colors in the shadows of the clouds to help tie your painting together.

- Keep your clouds moving—soft, blurred edges can help suggest movement and speed, especially in high altitude clouds.

- Some clouds, such as massing thunderheads, build slowly. Keep edges crisp and clean and the contrast strong for intense drama.

▶ CLARITY
What at first seems like a random mass of shapes must be made clear in the artist's mind. Remember, you are looking up at the relatively flat underside of a large, rolling plane of clouds. Sculpt and shape the shadows to create a sense of structure and solidity, keeping the perspective consistent. Strive to create a sense of light, mass, and volume in the lighter areas.

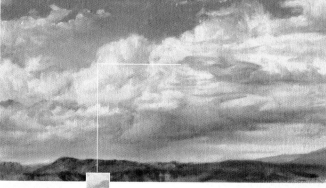

SHADOWS AND PERSPECTIVE
Stronger contrast will always advance, so darken the cloud bottoms as they come toward you, and look for areas where they can be set against large, light masses to increase the contrast and depth.

◀ CLOUD AS MOOD
Occasionally, ground and sky merge, clouds lose their sense of structure, and your sky becomes a stage for color, drama, and mood. Look for ways to suggest the familiar structures of the clouds. Even a hint of familiar shapes and patterns will convey to the viewer a sense of "sky," leaving you free to create the mood and a sense of drama in the rest of the sky without sacrificing depth in your painting.

DARK MASSES
There is just enough suggestion of shadowy cloud masses to give depth, scale, and structure to the rest of the sky.

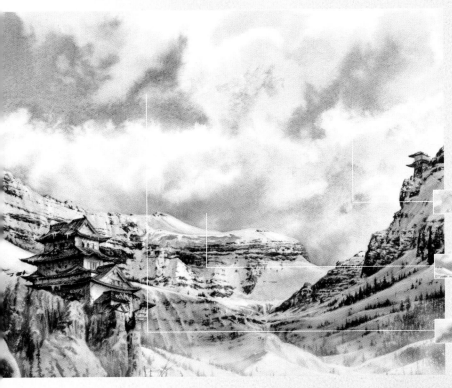

◀ BROKEN CLOUDS

Thin, broken layers of clouds seem to confuse artists the most. They can lack clear structure, their shapes appearing random, and often they are painted as meaningless blotches in a sky. Remember, you are looking at the underside of a thin, flat plane. Side planes will face toward or away from the light, and so be illuminated or in half light. Identify it that way in your mind, and you will find that you can see the structure and pattern even in broken clouds.

SIDE PLANE
This is essentially the side plane of the clouds, and provides visual clues to the depth and structure of the cloud layer.

GROUND SHADOWS
Ground color will reflect into the deepest parts of the shadows, unifying the painting.

WIND
Look for similarity of form and structure in the parts and edges of the clouds blown and shaped by the wind.

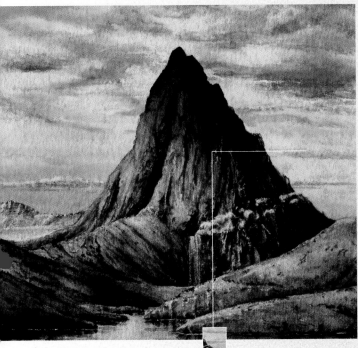

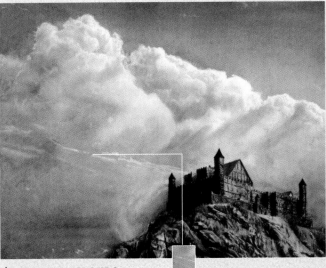

▲ CUMULUS CLOUDS

The large looming and shifting mass of storm or cumulus clouds has a definite structure, that helps give the clouds their incredible drama. They will have a sculpted look, which can be further enhanced by softening and darkening the undersides, allowing the rolling crown to stand out against the sky.

CLOUD BANDS
Smaller cloud bands in front of the main cloud bank give scale and majesty to the main cloud formation.

▲ GRAY SKY

Sometimes a bleak, featureless gray sky sets up exactly the mood you need. Since the sky will still establish the palette for the whole painting, be sure to mix the grays out of the same colors you intend to use for the ground plane elements, in order to tie the whole painting together.

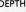

DEPTH
Minor value variations in the sky create depth and movement and keep the sky from flattening out. Even small suggestions of bands of cloud near the horizon will create enormous depth in your sky.

MOUNTAINS AND CAVES

Mountains are a wonderful dichotomy—a symbol of endurance and permanence, but also a vivid reminder of the violent forces that shape our world. Mountains figure prominently in myths and adventure stories. They are therefore a powerful tool for the fantasy artist, capable of linking the viewer to stories and sagas of mythic scope.

The massive scale of mountains and the constant interplay between them and the sky give the artist an unsurpassed opportunity to evoke drama, beauty, and poignancy. Whenever your images feature mountains, ask yourself what mood you want your painting to evoke—power, mystery, stark beauty, grandeur—then look for ways to bring that into your image. For example, a series of mountain peaks thrusting upward through clouds may convey a feeling of being all alone in an alien world. Add in the warm pinks of sunrise, and the feeling can change to one of watching the world's first sunrise. Shroud the peaks in mist, and you create mystery, suspense, and a realm of the unknown. Play with your composition and design until you find the solution that creates just the right mood.

TIPS

- Look for repeating patterns of structure. Every mountain has them.

- Mountain shapes range from thin spires to the traditional pyramid shape, and everything in between.

- Use a lot of the sky colors in mountains to keep the feel and lighting consistent.

- The high altitude of mountains means that, on clear days, colors tend to be brighter and shapes appear sharper and more clearly defined than you would expect.

- Make sure your mountains have a strong sense of mass and solidity in their structure.

▼ CAVE MOUTHS
Cave entrances are all about transition. The surrounding rocks and grasses must lead the eye inward, making a subtle and gradual shift to shadow and darkness.

▲ LAKES
Lakes form near passes and in the valleys of mountain ranges, continually refilled by the spring run-off. Make sure mountains around a lake appear as though they thrust right up out of the water, because in nature they do.

DARKNESS
Do not paint the darkness flat black. A warm, dark value close to black will have much more depth than straight black.

▼ MOUNTAIN VALLEYS AND PASSES
Passes often wind their way through a mountain range, forming low-lying paths that almost seem scooped out. Make mountain ridges and edges converge along this pathway, which will flare considerably at the ends.

◄ CHINESE MOUNTAINS

The various forces that create and shape mountains, and the different types of rock that compose them, give rise to a wide range of shapes for mountains. These steep-sided, foliage-covered mountains are typical of parts of China, but could suggest a world entirely alien to our own.

MIST
Mist is low-lying cloud, tattered and shredded by gentle winds. Be sure to suggest a consistent wind direction as you use mist to hide and reveal the various parts of your mountains.

▼ VOLCANOES
Unlike mountains, which are layers of the earth's crust thrust upward, volcanoes are continually formed and re-formed. The planes and folds tend to converge at the volcano's tip—or where the tip used to be.

SURROUNDING MOUNTAINS
Volcanoes are often much taller than the surrounding mountain range. Even a small indication of this can lend scale and presence to your volcano.

▲ CAVE INTERIORS
Because cave interiors are largely black, they often become a series of shapes and values. Drama and mood are the primary characteristics of caves, and they achieve their sense of structure through suggestion, or in details such as waterfalls or diffuse light.

▼ MOUNTAINS AND WEATHER
Mountains have an effect upon weather systems. Study the types of clouds and wind patterns typical of mountain ranges to give your paintings added realism, even in a fantasy setting.

SNOW LINE
The snow line is ragged, gradual, and at a consistent elevation horizontally across the whole volcano.

BUILDING CLOUDS
The clouds roll up to the mountains and crash against them, building and massing just behind the peaks, making the mountains seem impenetrable, while sheltering the valley.

FORESTS, TREES, FOLIAGE

Trees, shrubs, foliage, and forest bracken grow in an incredible variety of shapes, sizes, and colors, and can be found in almost every climate and region of the planet. They can be tall or short, broad or narrow, short-lived and frail, or have life spans of centuries. The differences are enough to keep an army of botanists busy, but they also all have important points in common, especially for the artist.

The most important characteristic for the artist to recognize is the strong sense of mass: of simple, large shapes interlocked and intertwined to create the larger whole. It is important not to get so caught up in the details of leaves that you fail to paint trees as solid, three-dimensional forms.

Branch patterns should also be considered. Branches do not sprout randomly from one another or the trunk. The branch pattern on an oak tree is different from that of a cherry tree, for example, and learning about the various patterns will make your own creations much more convincing.

▶ **BALANCE**
There is a clear branching pattern and structure to trees. It will vary from species to species, but one constant is the tendency toward balance. Look for a more or less equal spreading of branches in all directions, so that the trunk can support the branches as they grow over time.

SHAPING AND SHADING
Use the shapes of shadows and cast shadows to emphasize the three-dimensional structure of the tree.

OVERLAP
Let some of the branches overlap each other, as this will help to establish the tree in three-dimensional space.

GOLD LIGHTS
Golden sunlight breaking through the trees lends a soft, appealing element to your painting. Light is broken up and so creates a dappled look.

◀ **STRANGE BUT TRUE**
Learn to look for the unusual in nature. This entirely alien looking tree is actually a fairly common shagbark hickory. The more familiar you are with the wide variety that exists in nature, the easier it will be to invent your own worlds and make them look real and convincing.

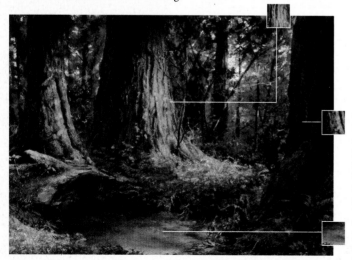

◀ **FOREST INTERIOR**
A forest can seem a confusing cacophony of color and light. Simplify what you are seeing into masses and structures, into large light and dark values. Once these are established, suggest details to create a sense of complexity.

COOL SHADOWS
Under a blue sky, cool blues and greens will predominate in the midtones, and be reflected in the shadows.

WATER
Murky water will reflect the light values well, but reflect the darker values poorly.

▶ **ANCIENT BARK**
Large, old trees have thick bark full of character and history, perfect for the fantasy landscape artist aiming to fill a world with personality and the sense of story that forms the backbone of so many fantasy epics.

▼ FOLIAGE AS MASS

When you begin to paint trees and foliage, it may help to paint them with only two values—a dark and a medium light. Craft your shapes carefully until they read correctly as three-dimensional, then you can add in the halftones, leaf clusters or individual leaves, color variations, and such, to give your image more subtlety.

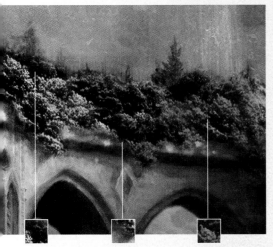

DARK SHADOWS
Light values on foliage are often closer to a midtone gray than white, and need a foundation of dark shadows to read correctly.

EARTHY SHADOWS
Warm browns often predominate in the shadows, reflecting the colors of the rocks and earth below the plants.

REFLECTED LIGHT
The upper surface of the leaves will reflect the sky colors, unless directly lit by the main light source.

▲ INTRICATE BRANCHING PATTERNS

If you were to climb an old tree and look outward, the complex interweaving of the branches would become very apparent.

SHAPES BEHIND THE MIST
Even trees greatly obscured by mist must maintain their distinctive shapes in order to read correctly.

TIPS

- The upper parts of leaves have a waxy coating that reflects sky colors, except under strong, direct sunlight.

- The undersides of leaves do not have the waxy coating, and because they face downward, they reflect the ground colors.

- In a close-up view, show leaves with bruises, discoloration, bite marks, and the like, for an added level of realism.

- Never mix a single color for trees and foliage. Small batches of color, each slightly different, will help create the variation necessary for replicating nature.

- Every landscape artist can learn from nature; it is a good idea to keep several reference books on trees and shrubs.

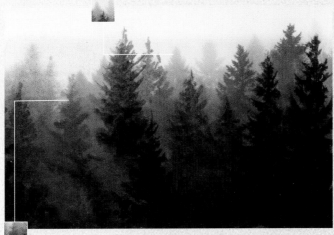

▲ SMOOTH BARK

Stark, sleek, fragile, and delicate are all words associated with thin, smooth bark. Use these strong associations in your images. For example, you might emphasize the value contrast in order to lend a stark, cold feel to a winter scene, or soften it to create a gentler setting.

MISTY SHAPES
The addition of mist simplifies the trees to strong masses and shapes, softening the edges and lightening the values considerably.

▲ CONIFEROUS SILHOUETTES

Coniferous trees are common in almost all northern latitudes and higher elevations. Because of their dark values, strong structure, and lack of large leaf surfaces, they can be reduced to a near silhouette.

SAND AND SNOW

Snow and sand may seem to have little in common, but both move and drift continually, their forms dictated as much by the wind as by the objects they cover or obscure, and both blanket the landscape, softening and hiding the shapes, giving the world a look that is sometimes bleak and dead, at other times fresh and beautiful. There is a harsh quality to both snow and sand—raw nature, untamed and reclaiming its own—and both transform the landscape into something alive, an integral character in the story.

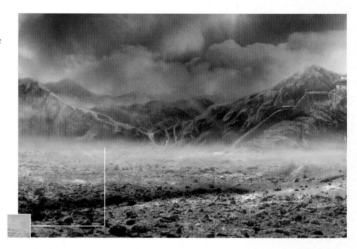

▶ ROCKY DESERT
Many sand and desert environments consist of flat lands or gently rolling hills covered with small rocks, as opposed to seas of sand dunes. Excellent for creating bleak, dead, or burned-out worlds, they suggest that not only does nothing live here now, but nothing ever did.

MIST ON THE HORIZON
Small amounts of sand will be stirred up by even the gentlest breeze, but its density will keep it close to the ground.

◀ WEATHERED ROCKS
Exposed to harsh sunlight, strong winds, and the abrasions of sand, rock faces will have a smooth, weathered, and ageless look to them, as if the rocks have been there since the world was formed.

SCRUB PLANTS
Sparse, stunted plants can give a much stronger sense of bleak and barren than no plants at all. They show how tough it is to survive the environment, without conveying the feeling of complete lifelessness.

▲ SAND DUNES
Just as the row of dunes will snake its way across the desert, the face of the dune itself snakes back and forth, creating long rows of interlocking shapes and the familiar dune pattern.

RIPPLES
There will be variations in the direction of the ripples, caused by variations in the wind strength and direction.

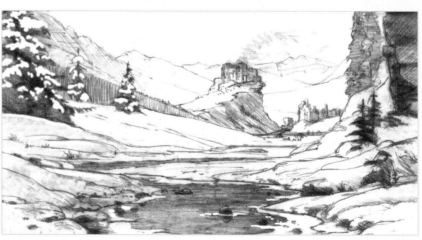

▲ HIGH CONTRAST
The high contrast of a winter scene gives you a strong tool for directing the eye of the viewer. Here, a low angle viewpoint combines with the folds in the hills, lines of the cliffs, and distant trees to help guide the eye straight to the point of focus.

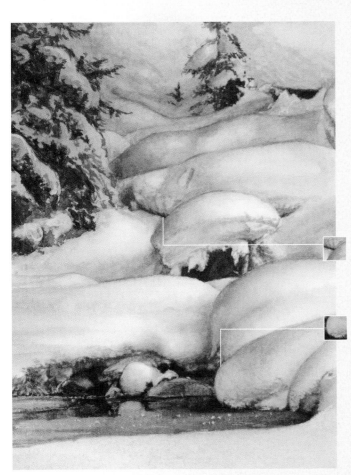

◄ HEAVY SNOW

The higher the elevation, the drier the snow. Dry snowflakes are smaller and are very powdery, tending to accumulate in thin layers on trees and rocks. Snow with more moisture, by contrast, is heavier, and accumulates in very thick layers with ease, such as the cap on the center rock and the blanket on the rocks near the water's edge.

UNUSUAL SHAPES
Look for large, unusual shapes and patterns in snowcaps, and remember that they will be larger than the rocks below them.

ROUND ROCKS
Individual rocks often become completely covered, becoming smooth, rounded shapes.

► SNOWCAPS

Even thin caps of snow can help define shapes and separate one object from another. These coverings of snow reflect very strongly in calm, open water, so they must be considered when composing the lights and darks of your painting.

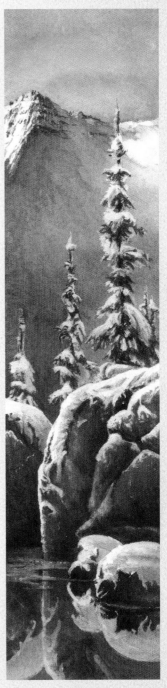

▼ ICICLES

Icicles form when there is just enough warmth to melt some of the snow, only to have it refreeze as it begins to run. They tend to form around caves, waterfalls, and roof edges.

LOCATION
Remember to place icicles at points where the melting snow would naturally pool and drip, not randomly.

TIPS

- Wind and water will both make the same ripple patterns in sand.

- Small amounts of vegetation make a desert look bleak and stark but not dead. No vegetation at all creates the look of a dead world.

- Snow is heavy, and accumulations on trees, grasses, and such will weigh down the foliage noticeably.

WATER AND REFLECTIONS

Water is nature's mirror. When water is very clear what you see is not the water, but rather the effect water has on the light striking it: the reflections and colors of the things around, above, and beneath the water, be it rocks, sand, or sky. Cloudy water minimizes these effects, but still, there is no inherent color to the water. What you see in cloudy water is the color of the silt or other particulate.

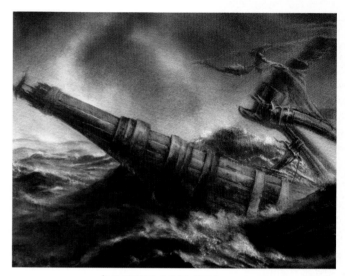

▲ ROUGH OPEN SEAS
The wind creates waves and increases their height and depth but will not alter their structure. Spray whipped up by the wind will obscure some of that structure, and may render the horizon invisible, adding motion and energy to your painting. Use visual keys such as bubbles, foam, and spray to communicate scale and intensity.

UPPER PLANES
The upper planes of the waterfall, rocks, and pool are painted with less bright, bluer tones to indicate overhead lighting from the sky.

BRIGHT LIGHTS
Warmer, more intense light strikes the side plane of the waterfall, creating the sense of late afternoon lighting.

◀ SMALL WATERFALLS
The shapes of the rocks that provide the structure and form of the waterfall should be visible, even if the water is relatively opaque. It is these rocks that change the water's direction, forcing it outward, inward, or dropping it off an edge. As water passes over the rocks, it will still have recognizable top and side planes, and your strongest light should strike one of them, not both.

WAVE SPACING
Waves tend to be evenly spaced, with perspective making them appear closer to each other the further they are from shore.

BREAKING WAVES
Waves will break gradually along their length, not uniformly or all at once.

◀ WAVES BREAKING
The crest of the wave is much thinner than the base. When backlit, this gives the top of the wave a glow, which can appear soft, inviting, romantic, or calming, and can provide a very interesting counterpoint or emphasis to the movement and rhythm of the water, creating highlights and color accents to unify or emphasize elements in the painting.

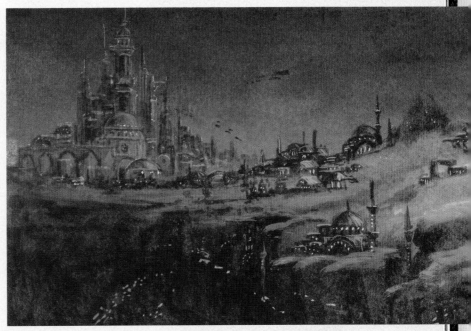

▲ STILL WATER
When an image is seen clearly reflected in still water, the reflection will appear darker than the original image.

CLOSE COPY
When an object touches the water surface, its reflection will be a near perfect replica of the original.

▼ MORNING MIST
On calm, hazy days, the border between sky and water can all but disappear. Faint waves may indicate distant water, but the horizon line is invisible, resulting in a moody, suggestive scene tailor-made for the fantasy artist.

▲ UNDERWATER
Because of water's density, it creates an effect similar to a very exaggerated atmospheric perspective in underwater scenes. Colors, values, and intensities all rapidly diminish with distance, fading into a deep, dark, homogenous color.

▶ LARGE WATERFALLS
A long fall produces a considerable amount of spray when it strikes the pool or rocks below, creating an atmospheric mist at the base of the falls.

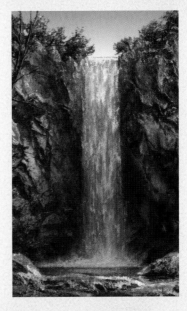

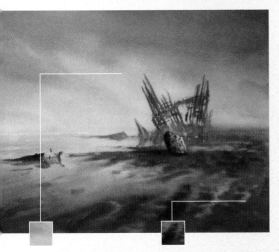

DIRECTIONAL SKY
Faint variations in the drifting mist give interest and direction to the sky, moving the eye toward the ruins on the beach.

SAND
The ripple patterns in the sand, and the water they collect, create a strong directional element.

IN AND OUT
Note how the blues push inward at point A, and the image reflection pushes outward a similar amount at point B.

▲ RIPPLES ON WATER
Ripples cause reflections to distort, so that they are broken and fractured. Streaks and flashes of sky will be interspersed in the reflections of objects, and often, the edges of these reflections will be shifted to the left or the right.

DARK WHEN WET
The base of the rocks are wet, and therefore, much darker than the rest of the rock.

CHAPTER 3

CREATING
FANTASY REALMS

Creating Fantasy Realms looks at the work of many of today's finest fantasy artists, and explores in detail both the choices made and techniques used in their work, as well as the reasons for them. Whether it's a choice of medium to achieve a desired effect, a compositional design choice, or the use of aerial perspective to achieve a certain emotional feeling or impact, all the choices leading up the final image will be explored in detail.

ANCIENT CITY

Tom Kidd wanted to produce a really big painting, so he chose an ancient city that had been built up over many centuries, a subject that allowed him to combine all aspects of his recently researched knowledge of architecture. Piranesi *is worked in oil paints, and the artist uses the fact that they are never perfectly opaque by underpainting in strongly variegated colors. Whatever you paint beneath will show through, and you can even control the translucency by choosing your paint carefully. For example, flake (lead) white is a warm and translucent white compared to titanium white. It's easy to test a color's opaqueness by running it across black. Many oil colors, like watercolors, are transparent; mixed with translucent color, they can have a very nice quality. The artist's plan was to create a picture composed of many distinct visual layers, using atmospheric perspective (see p. 46) to achieve this. He also plans visual masses (see p. 29) to balance the painting and prevent a complicated work from becoming too busy.*

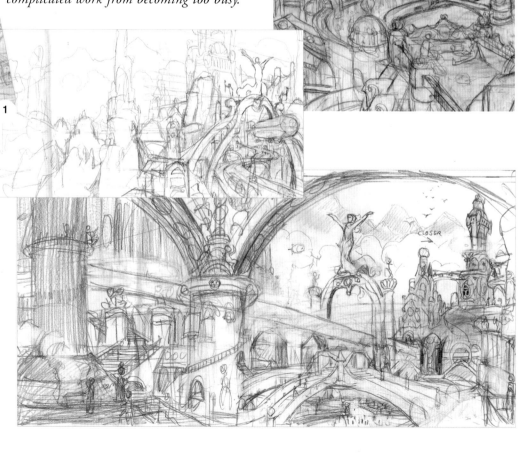

1. SKETCHES The artist likes to scribble, rather than draw when making sketches, and pulls together a great number of ideas from his stray lines. Rarely does anyone see these scribbles, but he keeps many of them and sometimes uses old ideas he had forgotten about for new paintings. After the scribbling stage, the artist makes a full-size drawing on tracing paper and traces back over the lines to transfer the image to the painting surface, which is why the lines on the worked up sketch (top right) have a heavy quality to them. The artist often makes notes on his drawings as ideas occur to him.

2. COLOR SKETCHES This massive project was going to take up a lot of the artist's time, so he wanted to make sure he got it right. With this in mind, he made a number of color sketches. The one shown is the one he followed most closely for the final piece, and yet it serves as the barest indication of his intentions.

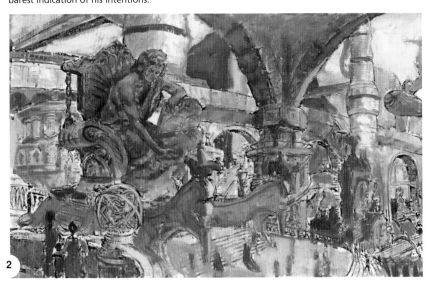

3. RESEARCH Although the artist always starts work with a pencil and a sheet of paper, he will often do research later, especially if something requires historical accuracy. In this case, the artist created a sculpture in air-drying clay from an image of a life model. This allowed him to solve lighting problems, and to see how well he'd visualized the statue in his painting.

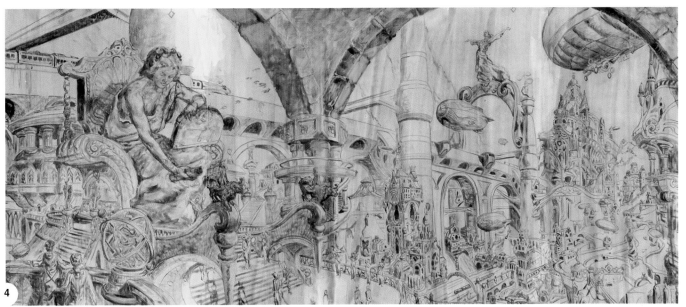

4. UNDERPAINTING Making an underpainting (see p. 15) allows the artist to lay in tonal values (see p. 30) in burnt sienna and burnt umber. This layer of the painting will completely disappear, and is used as a guideline only.

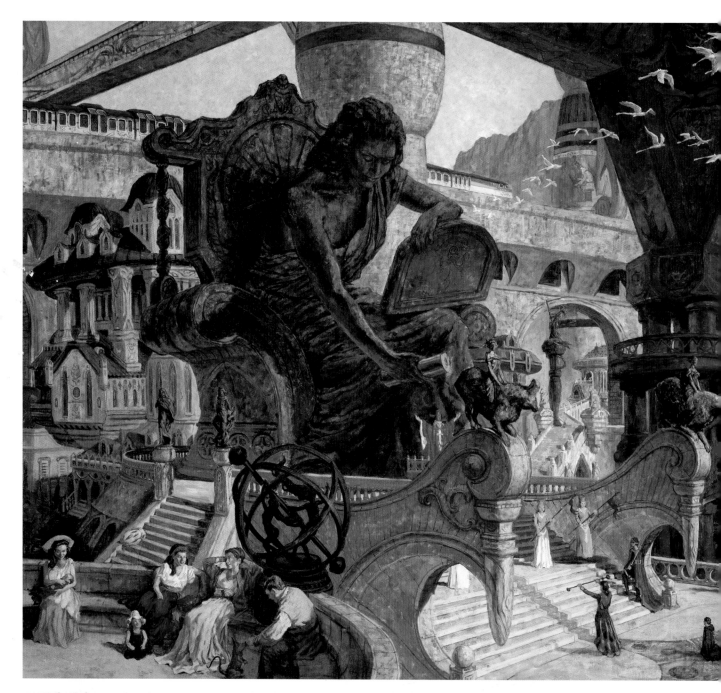

5. INITIAL PAINTING The artist paints drastically variegated color and tonal values into the underpainting. A great deal of this will show through in the finish. Much of the work at this point is about playing with the paint. The airship on the right is no more than a red glob.

6. TEXTURE Texture comes before form in Kidd's paintings; by varying the thickness of the paint as it comes off the brush, he can show more or less of the variegated underpainting as he wishes. When you look at the details you can see how the artist used the mottled underpainting to depict the ancient surfaces of the city.

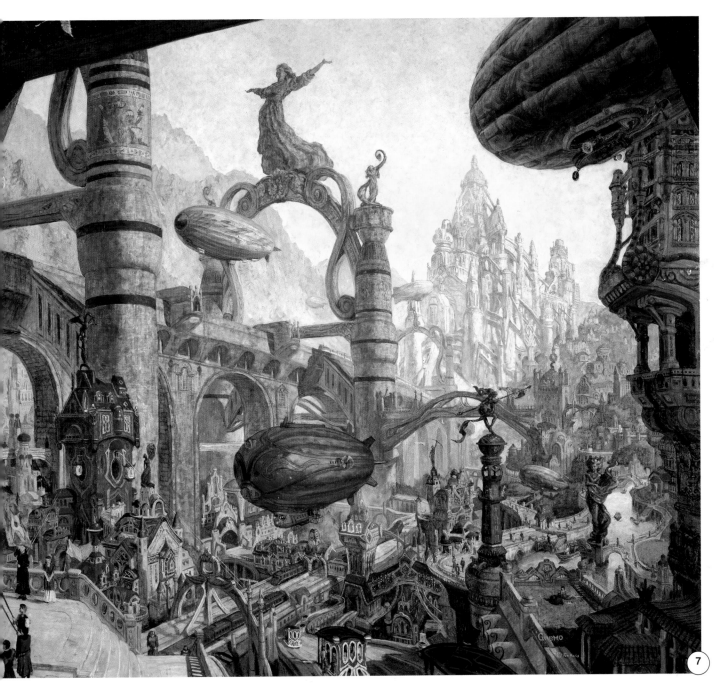

7. FINAL DETAILS Since he had decided that the mottled tonal variation in the underpainting wasn't enough, in the final stages, the artist painted in areas of blotchy white on the masonry, which look like aged stone or marble. The painting is named *Piranesi* after the 18th-century Italian artist Giovanni Battista Piranesi.

CITY OF THE FUTURE

The inspiration for Winsor McCay City *came to Tom Kidd on a bus in Manhattan, from where he saw a 19th-century building called the Ansonia, and imagined riding into an earlier New York—not on a bus but in an airship.*

The processes that went into the development of this piece show how illustrators need to make the right decisions as their work progresses, and be prepared to learn from their mistakes and make changes as needed.

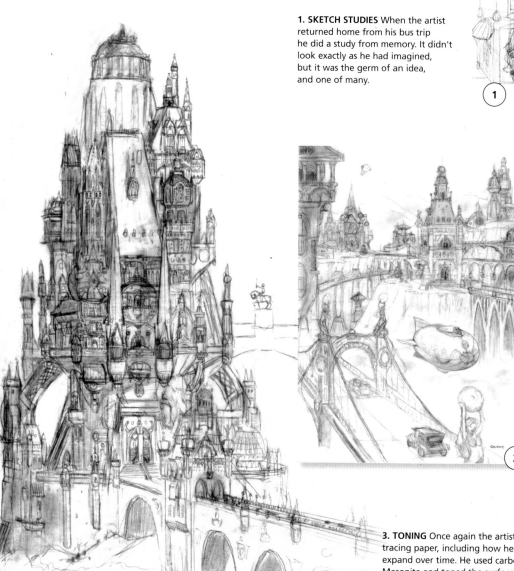

1. SKETCH STUDIES When the artist returned home from his bus trip he did a study from memory. It didn't look exactly as he had imagined, but it was the germ of an idea, and one of many.

2. MAKING MISTAKES The artist often starts with a small idea and expands on it. After making the initial drawing he worked on several thumbnail sketches and ultimately came up with a composition he liked.

The artist then drew the entire picture to full scale on tracing paper, which can be a good way to work out the kinks in your drawing. He realized that he didn't like it. It needed to be more spectacular, so he did a few more thumbnail sketches and came up with a castle whose main structure grew over time. The original composition needed an even more important center of interest. It needed to be monumental, ridiculously so.

3. TONING Once again the artist drew the latest composition to full scale on tracing paper, including how he thought the structure would be added to and expand over time. He used carbon paper to transfer the drawing to gessoed Masonite and toned the surface with a wash of burnt sienna. This seals the drawing and gives a nice color to work over: it also sometimes smears the drawing a little, although this is not something to worry about since you still have the original to refer to.

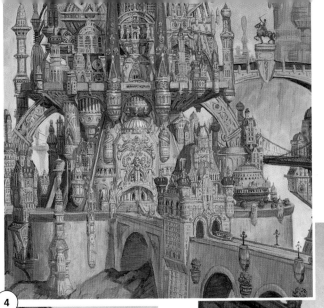

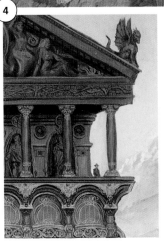

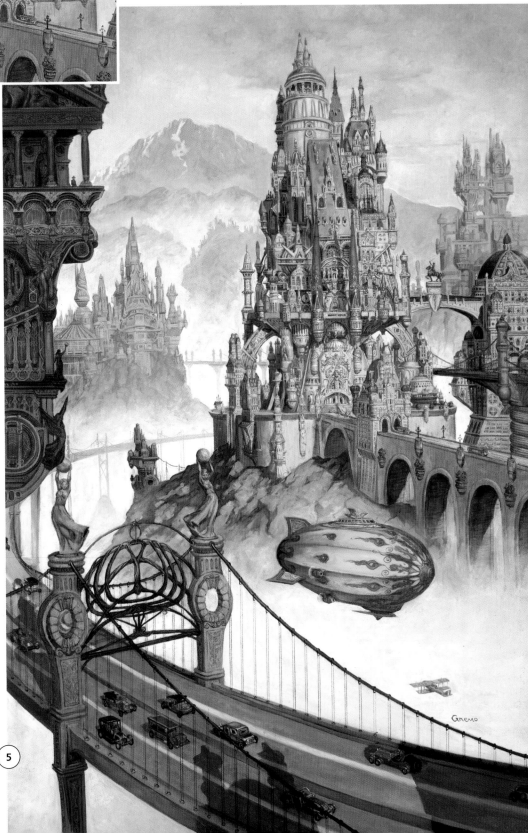

4. WORKING OVER TIME The artist worked on this piece between his regular illustration work, so sometimes a couple of weeks went by before he could return to it. He found that mixing his colors ahead of time and submerging the palette in water in between kept the oil paint he was using wet, and meant he could lay in the texture and shapes of the main building as flat shapes and add the shadows and form later in a series of translucent glazes (see p. 15). Then he went back with the wet paint from the same palette to add details, such as the little filigrees in the windows. This allowed him to skip the color sketch stage and work out the colors for the painting in a rough manner, first adding simple shapes, and then adding details on top of details.

5. FINISHED PICTURE Painting in the forms first as flat shapes meant that the values (see p. 30) and masses (see p. 29) were well established, creating a strong composition. The translucent glazes then brought volume and three-dimensional form to the buildings.

AQUA CITY

For Aqua City, Anthony Waters envisioned the waterworks of a vast city which sprawls over an entire planet. Using sweeping curves instead of sharp corners, he began to lean on the work of architect Antoni Gaudi for inspiration. The forms became organic, with a visual presence of metals like copper and steel, all patinated by many ages of contact with water. The composition was sketched out by hand, scanned, and then painted in Photoshop. The artist also used scanned photographs of interesting textures in the image.

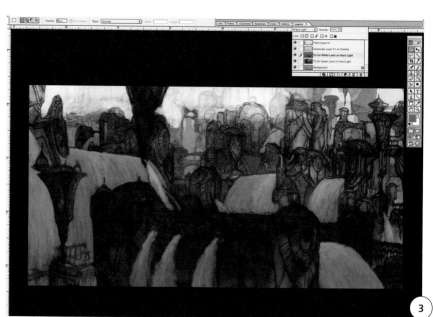

3. DIGITAL THUMBNAIL The artist scans his sketch and reduces its size in order to create a digital thumbnail to use as a starting point for the painting. He finds this gives him a chance to experiment and work out any potential problems before he starts on the main piece. Using Photoshop, he applies colors on a new layer (see p. 17), preserving the original drawing.

1. LOOSE SCRIBBLES Most of the artist's paintings start as loose scribbles, and this composition was chosen from a dozen or so sketches.

4. BEGIN RENDERING Time to start painting. Keeping the brush size large, the artist establishes the waterfalls and then begins painting the city, working quickly over the background elements and focusing on large shapes.

2. REFINING THE SKETCH Here, the scribbled idea from step 1 is taken to a higher level of finish.

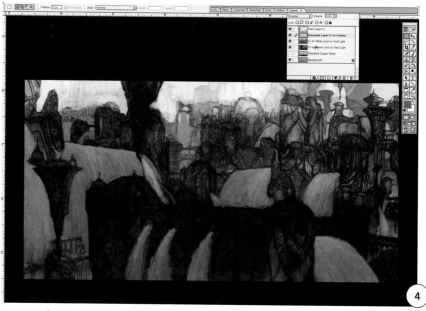

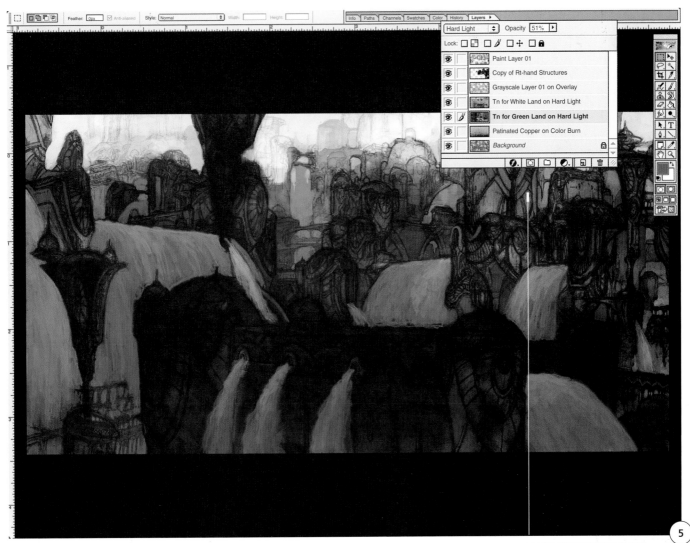

5

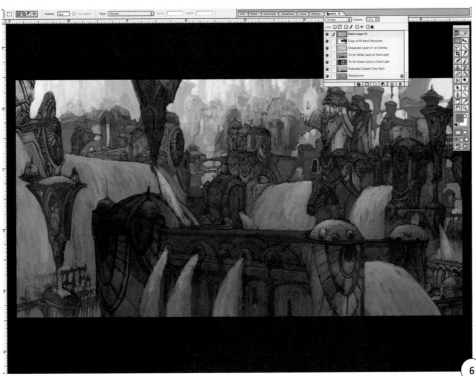

5. MID-GROUND WORK With most of the horizon nearly complete, rendering begins on the mid-ground structures. A scanned photograph of some patinated copper is introduced to establish a foundation for texturing the foreground building.

6. VALUES Most of the work at the lower end of the value scale—the range of light to dark in the image (see p. 30)—has now been dealt with. The darker values must be established first, in order to create a foundation on which to apply the lights.

6

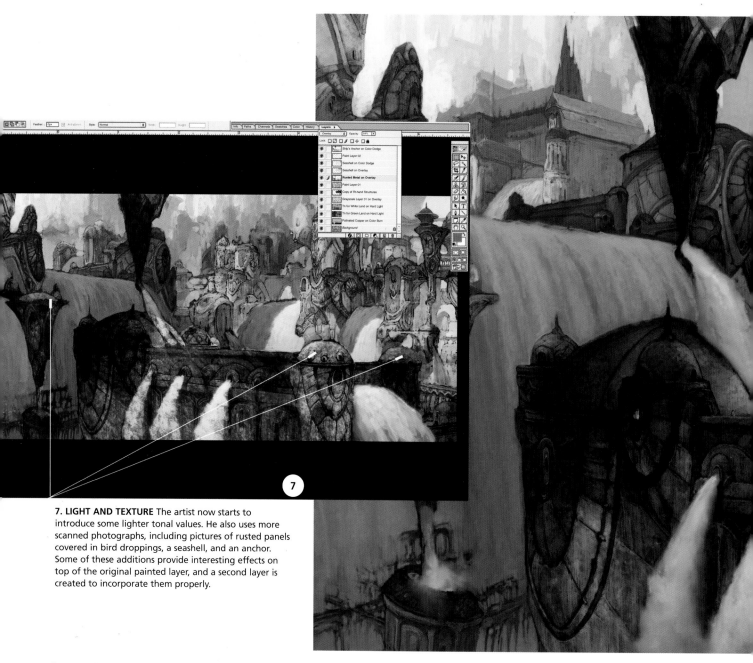

7

7. LIGHT AND TEXTURE The artist now starts to introduce some lighter tonal values. He also uses more scanned photographs, including pictures of rusted panels covered in bird droppings, a seashell, and an anchor. Some of these additions provide interesting effects on top of the original painted layer, and a second layer is created to incorporate them properly.

8. UNDERPAINTING The digital thumbnail file is flattened (see p. 17) and added to the full-size working file to be used as an underpainting. Enlarging the thumbnail softens the forms, enhancing the atmospheric perspective in the background (see p. 46). The mid-and high-range grays are lifted from the original underdrawing and applied to their own layer to preserve the linework from the drawing while painting begins again.

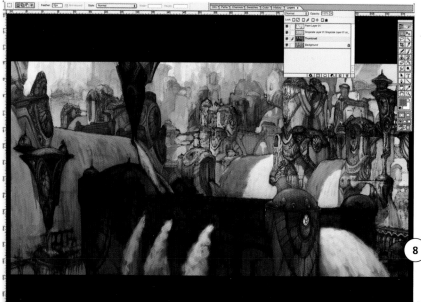

8

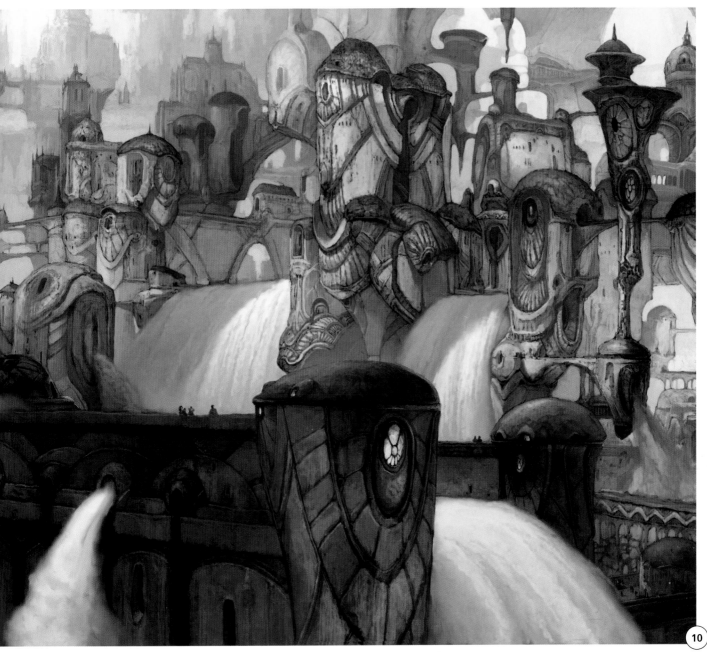

10

9. MAKING DECISIONS By shifting things around the artist can see how various elements work. He decides to keep some of the hot, bright colors in the foreground because they make the towers feel rusty.

10. FINAL TWEAKING The water is tweaked, and the foreground buildings made to look old and worn. People are added to the final product to provide a sense of scale, while modifications to the background shapes make the cityscape seem less eccentric.

9

FOREST CITY

When creating Sacred Grove, *Anthony Waters imagined vast cathedral-like greenhouses, part of a planet-sized city, miles deep, and with the look of 15th-century Eastern Europe. The vast shapes of the cathedral-like greenhouses were directly inspired by Antoni Gaudi's* Sagrada Familia, *and the artist deliberately used natural forms for the building supports, making columns like tree trunks, and covering everything with moss and other growing things. The buildings are meant to suggest the softened forms of the forests they harbor. Using Painter and Photoshop the artist creates digital art with the characteristics of traditional painting.*

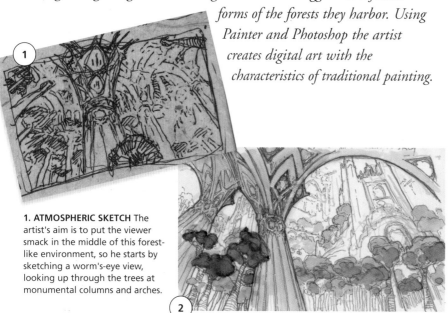

1. ATMOSPHERIC SKETCH The artist's aim is to put the viewer smack in the middle of this forest-like environment, so he starts by sketching a worm's-eye view, looking up through the trees at monumental columns and arches.

2. TIGHTER SKETCHING From the first sketch a second, tighter, and cleaner version of the same idea is roughed up. In this red ink sketch the viewpoint is still looking up at the arches of a building's interior, but close enough to the threshold that the outside is also visible. More cathedrals are visible in the background.

3. FINAL SKETCH A final, even tighter version of the sketch has been created incorporating less foreground architecture. This will become the underdrawing for the painting.

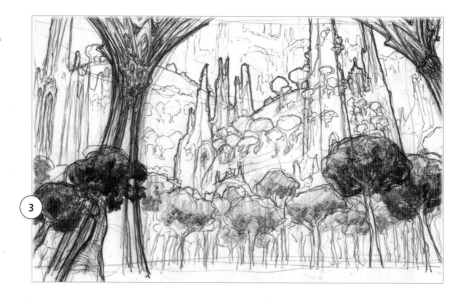

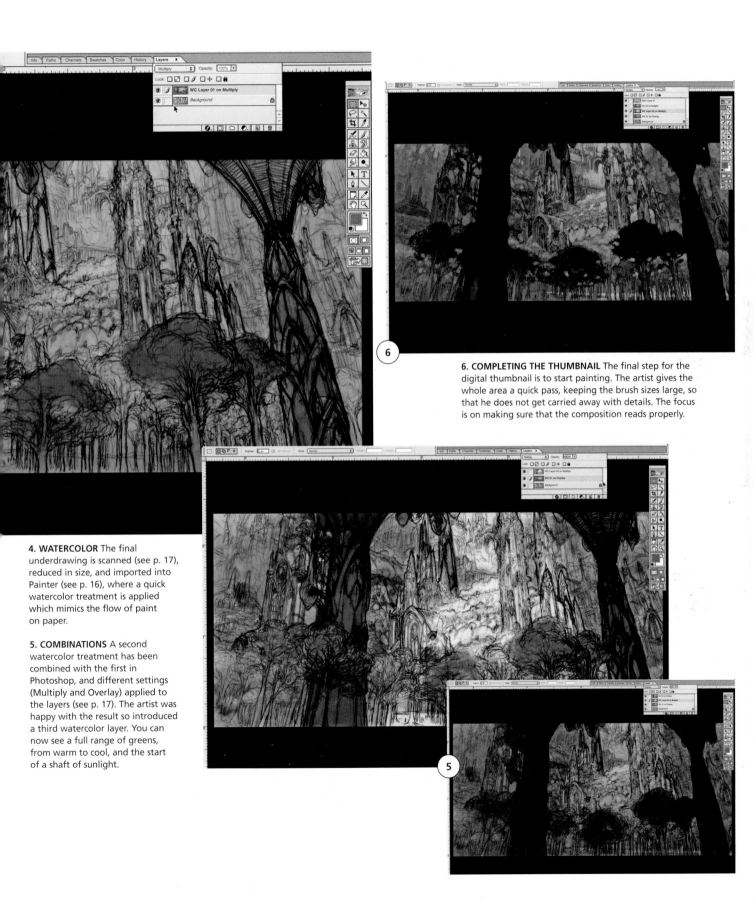

6. COMPLETING THE THUMBNAIL The final step for the digital thumbnail is to start painting. The artist gives the whole area a quick pass, keeping the brush sizes large, so that he does not get carried away with details. The focus is on making sure that the composition reads properly.

4. WATERCOLOR The final underdrawing is scanned (see p. 17), reduced in size, and imported into Painter (see p. 16), where a quick watercolor treatment is applied which mimics the flow of paint on paper.

5. COMBINATIONS A second watercolor treatment has been combined with the first in Photoshop, and different settings (Multiply and Overlay) applied to the layers (see p. 17). The artist was happy with the result so introduced a third watercolor layer. You can now see a full range of greens, from warm to cool, and the start of a shaft of sunlight.

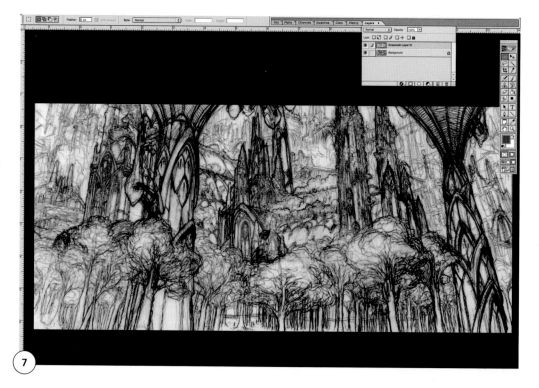

7. GRAY TONES A more detailed, full size sketch is imported; this will overlay the digital thumbnail. The mid-and upper-range grays are separated and applied to their own layer to preserve the linework from the original sketch while painting begins again.

⑦

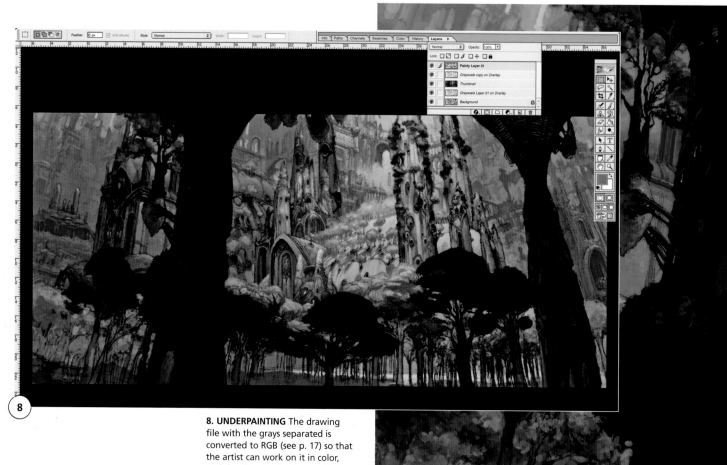

⑧

8. UNDERPAINTING The drawing file with the grays separated is converted to RGB (see p. 17) so that the artist can work on it in color, and the thumbnail is brought in to act as an underpainting. Enlarging the underpainting softens the forms in the background, enhancing the atmospheric perspective (see p. 46) and making the mid-and foreground objects appear crisper.

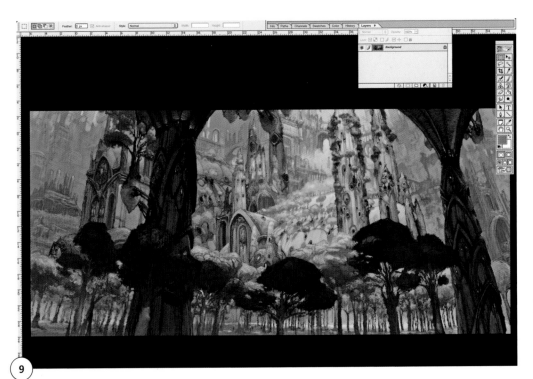

9. REFINING STAGES Once the background and mid-ground are taken care of, there's just some refining left to do. Lights in windows bring the building to life and little figures among the foreground trees show how big the setting is.

10. FINAL FLOURISH The foreground has been lightened in the finished painting so that the details don't fall away into blackness, and a blue glow has been added to the people in the forest to make them a little more apparent.

9

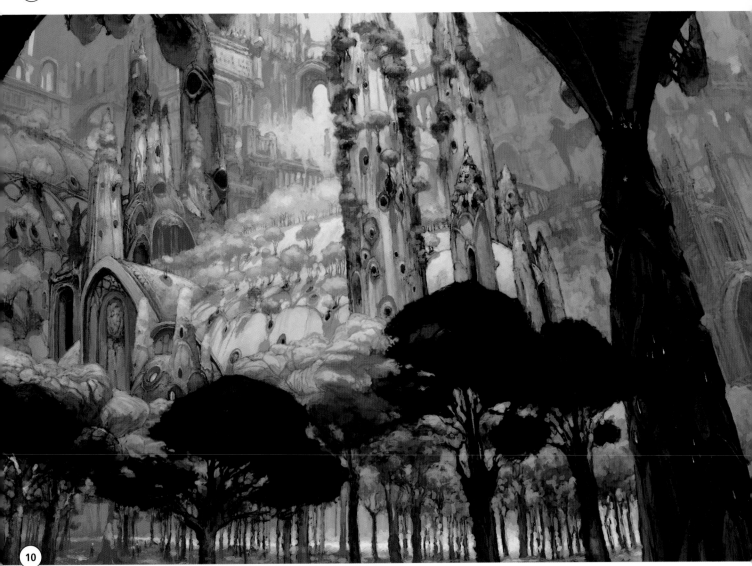

10

SUBTERRANEAN CITY

Subterrane *is a painting arrived at by spontaneous means. The artist did not produce a sketch and began work only with the brief to produce a subterranean fantasy landscape. Alan M. Clark has a unique way of working that he calls "controlled accidents." The term refers to the image-generating techniques he uses to help him discover subject matter. This involves pushing acrylic paint around the painting surface using various "tools." The results are suggestions of texture, shapes, and contrasts, at times almost photographic.*

1. CONTROLLED ACCIDENTS The artist uses household objects to manipulate paint on the painting surface, which is usually a smooth, primed hardboard. Possible tools include rags, plastic sheeting, aluminum foil, stiff acetate, rollers, stiff boards, balloons, even blowing the paint with a vacuum cleaner hose on exhaust.

2. BALLOON EFFECTS For this painting the artist works with acrylic paints. A gessoed hardboard is painted with varying shades of very dark blue, purple, and green. Once this has dried, the surface is brushed with varying shades of brown. The wet paint is then pushed around with a long, thin balloon. The balloon can be rolled, slid, compressed, bounced, and twisted through the wet paint for a variety of effects.

3. FORCED HALLUCINATION When the paint has dried the artist looks at the resultant sinewy forms, and uses what he calls "forced hallucination" to find potential subject matter within the intriguing but often nondescript images generated by controlled-accident techniques. Just as one might see faces in woodgrain or animal shapes in clouds and rock formations, the artist finds images in the paint and decides where he wants to go with them before adding color and contrast with brushes.

4. CREATING DEPTH Blue is added to create depth and to separate foreground shapes from the background. Some shapes are stained lightly with blue so that they seem to disappear into the hazy distance.

5. LIGHT AND SHADOW Shadows and highlights are added to fill out the forms. The shapes are firmed up and given texture where they are lacking, including on the stairways. Silhouettes of far-off shapes are used to further break up the distance.

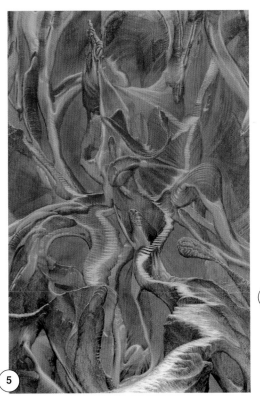

6. COMPLETING THE SCENE Red is added to the foreground shapes and their backward-wrapping edges are lined with blue to enhance the illusion that they are backlit by the distancing blue light. Windows and doors have been added simply by suggesting that orange light emanates from within the forms through rectangular openings. The rows of windows, which diminish in size as they disappear into the distance, support the perspective (see p. 38) created with the blue haze.

ANCIENT PLACES

When creating Ancient Places, *Rob Alexander imagined a world that was a cross between traditional Tolkien fantasy and feudal Japan. He asked himself what sort of living tree homes would Japanese elves build? Then, following a process where the artist "let things come out of the pencil on their own," the image evolved from a simple sketch to a two-panel panorama, and finally, to a complex four-panel composition.*

2. EVOLUTION Once the idea was firmly established in the artist's head, it was time to develop the idea. Working on 11 x 14 in. (28 x 36 cm) pages, the artist allowed these two drawings to evolve naturally, guided solely by the initial idea. At this point, he had not gathered any reference or looked at anything which might influence or dilute the idea.

1. THE BEGINNINGS OF AN IDEA
The germ of the whole painting and the entire forest realm was started with the artist's question: "What sort of living tree homes would Japanese elves build?" This rough sketch was the first response to that question.

3. CREATING A SENSE OF PLACE
Next, the two drawings were spliced together and fleshed out considerably, creating a much more complex and complete story and sense of place. The aim was to create an elaborate forest realm with a sense of history and culture, and make it seem real. At this point, the artist studied reference books of Japanese forests, shrines, and architecture to give the drawing a sense of realism and complexity that brought the world to life more fully.

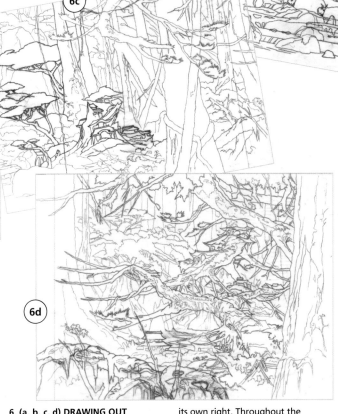

4. COLOR STUDY The drawing from step 3 was then scanned into the computer and given a simple color treatment in Photoshop (see p. 16). This color piece was a style guide: it needed to sketch out enough of the forest to spark the imagination and give a firm direction to go in.

5. (a, b, c) EXPANDING THE COMPOSITION The artist took the conceptual art and came up with four final forest illustrations. The aim was for them to fit into one long panorama. Because the piece had initially been designed as a two-panel panorama, the artist opted to take that design and enlarge it into a four-panel composition. These are the thumbnails that worked through that process. Sketch 5c shows the original two-panel piece forming the first and fourth panels.

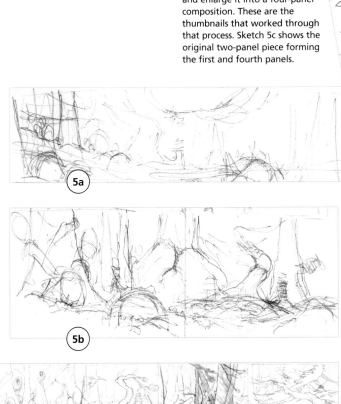

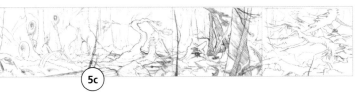

6. (a, b, c, d) DRAWING OUT Working from the two original 11 x 14 in. (28 x 36 cm) drawings, the artist made changes to allow them to form the ends of the panorama, and drew out the middle two panels. Each drawing was on a separate page—for workability and to allow the artist to be sure each panel would hold up as a drawing in its own right. Throughout the drawing process, the artist constantly placed the drawings next to each other to make sure that the entire painting would hold together, as he knew he would be painting the image as one long panorama on a single piece of paper. The four drawings were then transferred to stretched watercolor paper.

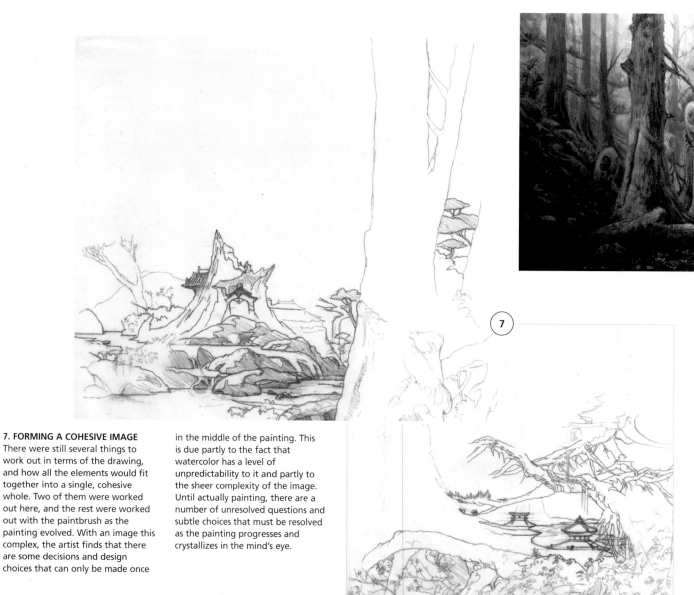

7. FORMING A COHESIVE IMAGE
There were still several things to work out in terms of the drawing, and how all the elements would fit together into a single, cohesive whole. Two of them were worked out here, and the rest were worked out with the paintbrush as the painting evolved. With an image this complex, the artist finds that there are some decisions and design choices that can only be made once in the middle of the painting. This is due partly to the fact that watercolor has a level of unpredictability to it and partly to the sheer complexity of the image. Until actually painting, there are a number of unresolved questions and subtle choices that must be resolved as the painting progresses and crystallizes in the mind's eye.

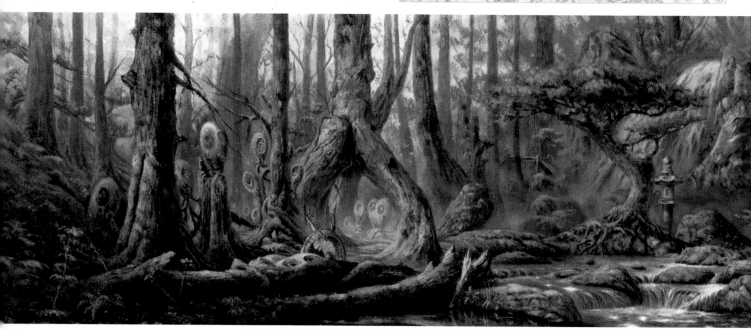

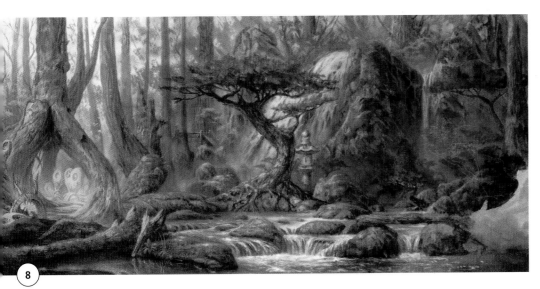

8. THE PAINTING Working from left to right, and from background to foreground, the painting gradually takes shape. Initial washes (see p. 11) cover a large area, which is then slowly refined and resolved. A lot of water is used at first, with successive layers of paint having less and less water in them. Atmospheric effects are hinted at but left largely until the very end. They will be added with opaque paint. Because they are light in value, they are used to balance out the areas of light in the image—something that can only be done accurately once the rest of the painting is complete.

8

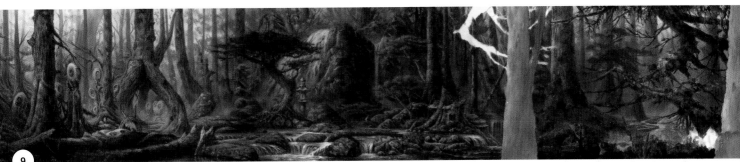

9

9. ESTABLISHING STRUCTURE Here you can see the evolution of a section. Light washes cover the right end of the painting, structure has begun to be established in the various elements, and the values (see p. 30) have begun to be laid in. The final design of the edge of the waterfall is still being created, and the interplay of branches and houses in the mid-ground has yet to be finalized.

10. THE FINAL PIECE The highlights have all been added and balanced, final color corrections laid in, mood and atmosphere enhanced where needed, and final details such as leaves and branches have been painted. The artist then stood the painting vertically against a wall and studied it from far enough away to see it all at once, both as it is and as a reflection in a mirror. Final adjustments were made in order to make sure that the painting as a whole held together strongly. This involved nudging the values here and there, either to make some of the forms read more clearly, by separating the mid-ground and background elements, or else to harmonize values and bring them closer together to create a strong sense of mass (see p. 29) and solidity.

10

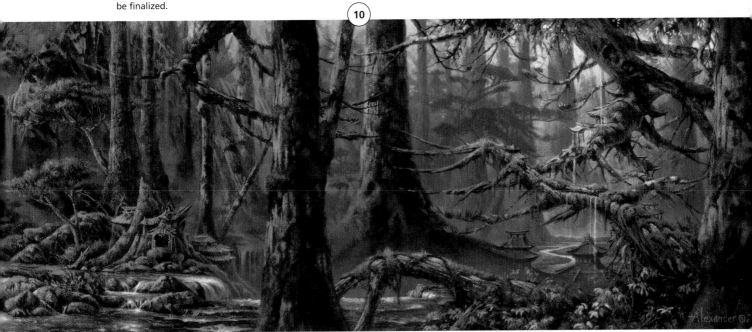

FOREST SETTING

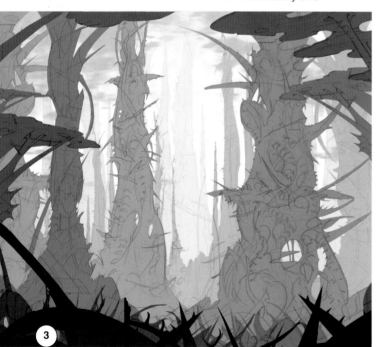

When creating Mirrodin Forest, *John Avon's aim was not only to illustrate a metal forest, but to show how a final painting can have all the energy of the original sketch.*

Working with both digital and traditional art, the artist feels he gets the best of both worlds. Photoshop allows him to keep tweaking and retweaking his work, and provides him with endless opportunities to "feel" how the design is progressing. Toward the end of the process, however, he prints out the work, giving a physical end result on which to add in the final details with acrylic paints and marker pen.

(1)

1. LINE SKETCH The artist starts work with a line sketch. He considers this stage to be the most critical and creative of all, where the initial vision is brought out of the imagination. His aim is to get as much movement as possible into all the lines.

2. TONAL VALUES The artist scans in the sketch (see p. 17), and then "selects" on the computer all the prime elements so that each can be modified separately (see p. 17). Values (see p. 30) are simple, with dark foreground elements moving to lighter backgrounds. Because each tree is independent, the image can be tweaked at any time.

(2)

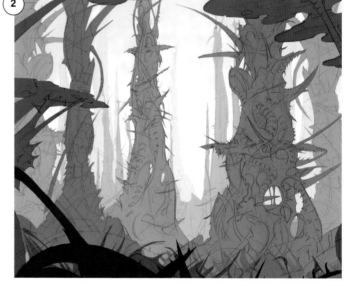

(3)

3. INTRODUCING COLOR Having established the approximate tonal perspective, each element can now have its own color variation applied. The artist plays with warm greens and browns in the foreground, going to colder blue-greens at the back.

4. ADDING FORM AND LIGHT The artist puts in lighting from the left side and adds shapes within the trees. Learning when to stop is an important part of the process, and here the shadow areas contain almost no information, allowing the emerging detail to stand out strongly.

(4)

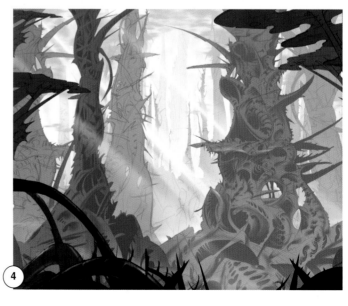

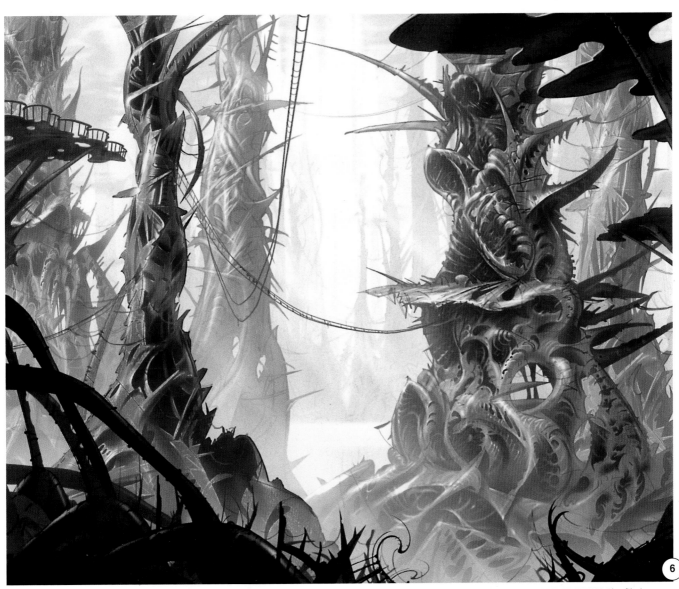

6. HAND CRAFTING The file is printed out and mounted on hard artboard, and the very end elements are added using acrylic paints, and even a black marker. Don't be afraid to leave some areas unfinished. Here some of the original lines have been deliberately left showing through, to give an almost comic-book feel.

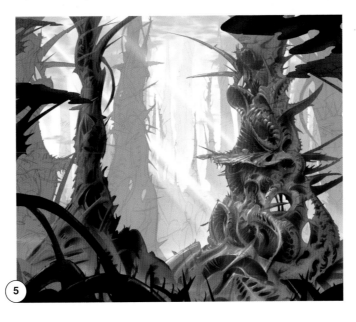

5. DETAIL AND BACKGROUNDS When he is more than halfway through, he begins picking at areas, working all over the image. One area of the work reveals a clue to another, and the artist will never finish one element in one go. As he gets more confident with one tree's shape he works on another, with each inspiring the next. Light is the clue to atmosphere, so a few sun rays hitting the trees help create a mood.

SAVANNAH

When she created Meyerworld 1, 2, 3, *Ilene Meyer wanted the final piece to be a triptych that could be arranged in any sequence, but equally, where each element did not require the other for balance.*

The artist begins work by making quick sketches in felt pen which explore rhythmn and movement, once this is established she introduces representational subject matter.

1. INITIAL WORK The artist makes preliminary draft sketches using felt pen, spending only one to two minutes on each: she finds that the quicker she works, the better.

2. COLOR SKETCH Pen and watercolor are used to make rough layouts with possible colors. Again the artist works quickly.

3. LINE AND SHADE After transferring the layout to the canvases, the artist darkens the lines and adds some shading using thinned oil paint. She doesn't usually tone the canvas until after this stage. As you can see, many changes were made after the rough was transferred to the canvases.

4. PRELIMINARY COLOR The basic colors are painted in using thinned oil paints. Note that you can still barely see the lines in the mountains and sky because all of these shapes must line up with the adjacent panel.

5. DEFINING LINES More color is thinly applied to the foliage. The checks are defined and the continuing motion of where the ending lines of the checks lead to the next canvas is also clarified. All three elements together now show a more visible rhythm. The globes are painted.

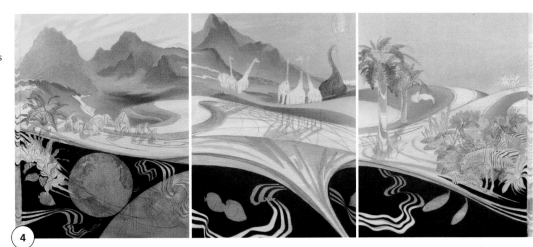

4

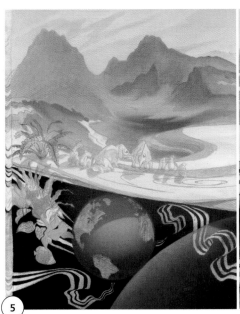
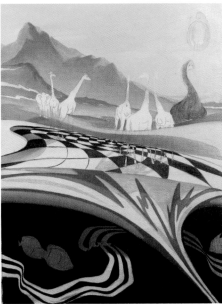
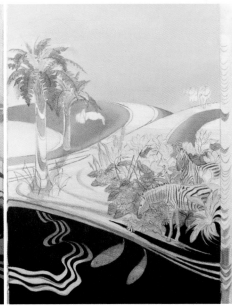

5

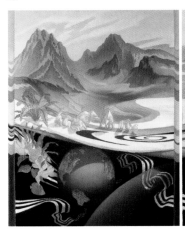

6. CONNECTING COLOR When the globes are dry, a glaze of alizarin blue, ultramarine violet, and blue-black is applied to the lower area, including the globes. All three have to be the same color, at least where the ends meet. The hills and the rest of the landscape are now being connected by color.

6

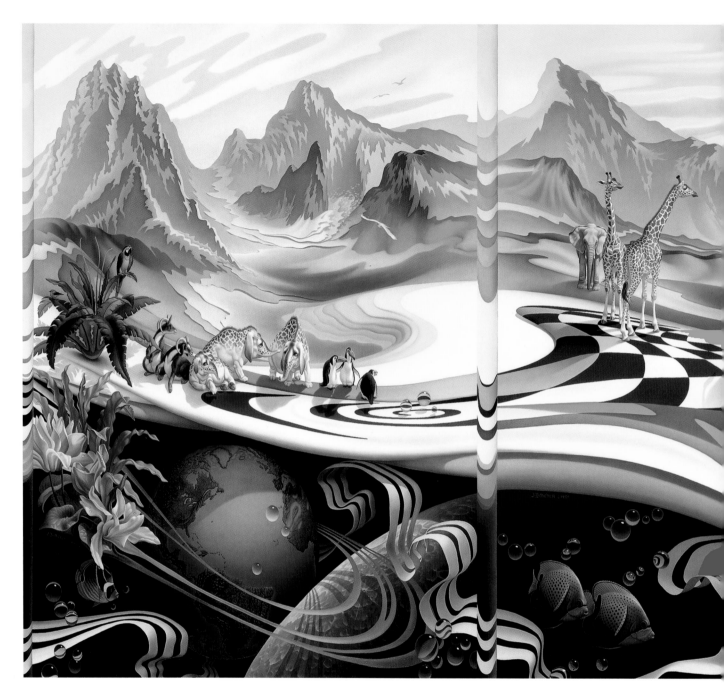

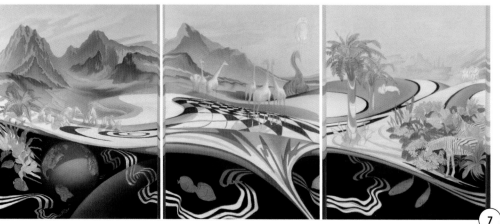

7. GLAZING (see p. 15) Some of the sunset is painted, the hills are given a pink glaze to refine the tone, and the orange is glazed with manganese blue to kill the red. The pillars that mark the meeting point between the canvases are measured and defined. Much shifting of the three canvases is required to keep the lines and colors working together.

7

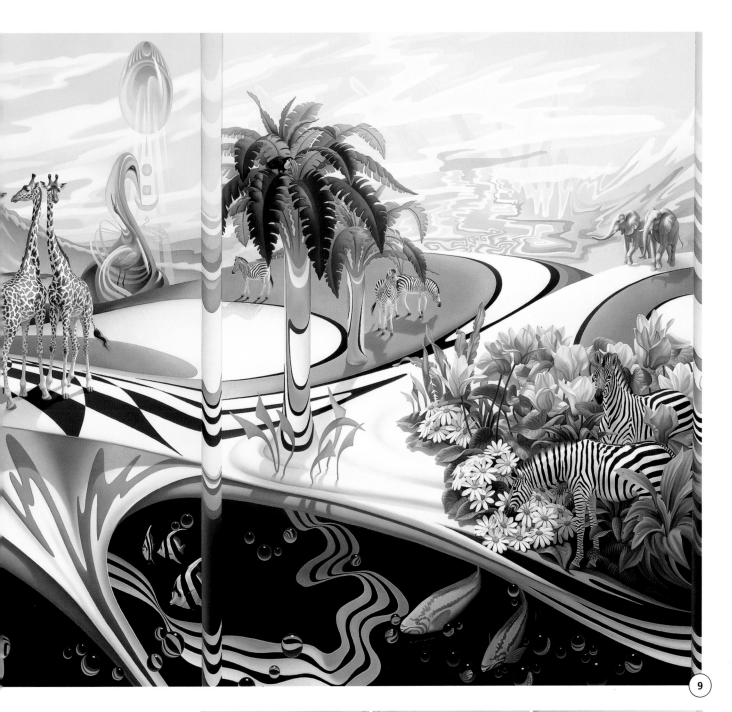

9

8. COLOR REFINING More of the sunset is now painted, as are the clouds in all three canvases. Some of the hill color is refined and more work is done on the side pillars.

9. FINISHING TOUCHES Toward completion of the painting, the artist glazes the pillars so they have a glass-like appearance, and refines the colors to match exactly.

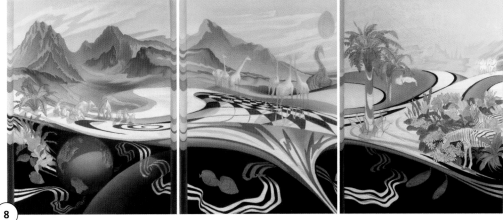

8

MOUNTAIN RANGE

To produce Spirit Rising, *Christophe Vacher used oil paints on canvas, beginning with a burnt-umber underpainting before rendering the background and character, working from the furthest point to the closest. This is just one of the methods of work he sometimes uses. At other times, for example, he may first block in general colors all over the canvas before getting into the details.*

Vacher's final image is always about stylization, clarity, and balance, and when he takes a last look over the painting he tries to be as critical as he can be of his work. If a particular area has been nicely worked, but gets in the way of readability or clarity of the whole image, it must be simplified.

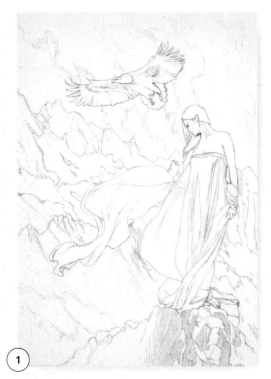

1

1. THE SKETCH Work begins with a sketch, made on paper first, then blown up onto canvas using a proportional grid. This process gives the artist the opportunity to carefully think about composition, proportions, and how the different shapes relate to each other.

2. THE UNDERPAINTING (see p. 15) The artist uses a layer of burnt umber oil paint to define volumes and lights with clarity. Another warm color could be used, but burnt umber, thinned with turpentine, offers a good range of tones. The idea is to be able to paint over this warm layer later using different thicknesses, letting the warmth show through here and there, and letting it play with cooler colors added on top. It is always easier to cool down a color than to warm it up.

2

3. THE SKY Here, we can see how the underpainting is used with the colors of the sky, especially in the clouds, where the balance between cools and warms is particularly important to give a slightly translucent effect. The clouds also need to acquire volume and three-dimensionality without losing their softness.

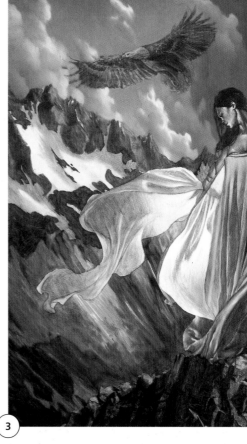

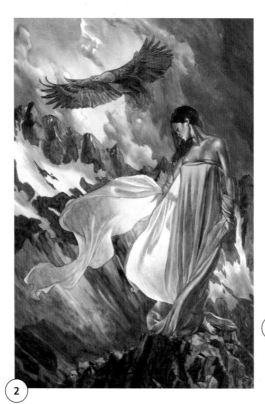

3

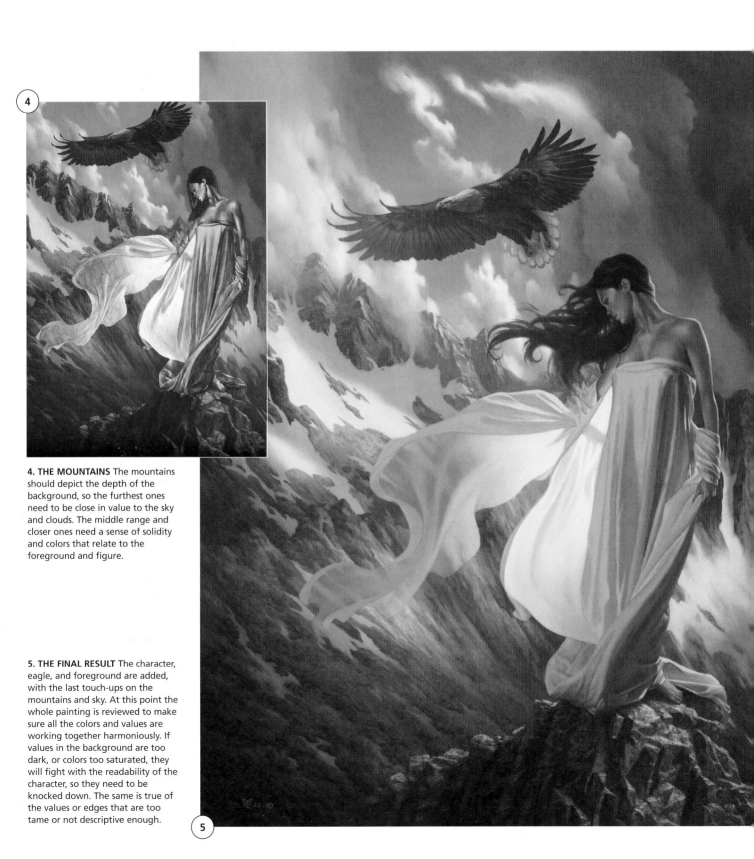

4. THE MOUNTAINS The mountains should depict the depth of the background, so the furthest ones need to be close in value to the sky and clouds. The middle range and closer ones need a sense of solidity and colors that relate to the foreground and figure.

5. THE FINAL RESULT The character, eagle, and foreground are added, with the last touch-ups on the mountains and sky. At this point the whole painting is reviewed to make sure all the colors and values are working together harmoniously. If values in the background are too dark, or colors too saturated, they will fight with the readability of the character, so they need to be knocked down. The same is true of the values or edges that are too tame or not descriptive enough.

SEASCAPE

For Donato Giancola, the initial stage of creating a painting begins with abstraction. He uses graphite on white or toned paper to produce graphic thumbnail sketches, from which he can determine and select a compositional approach that will hold together from the small to large format. The strengths of graphic design and modern aesthetics—for example, color fields, mass and vector relationships, and high/low contrast changes—provide him with a strong compositional groundwork upon which to construct the final illusion. Backed up by sourced reference material, a color rough in acrylic and oil paints gives shape to the final oil painting.

1. ABSTRACTION The artist begins work on *The Mistress* by making a series of thumbnail studies. Through this process, he determines and selects a compositional approach that will hold together from a small to a large format.

2. LARGE ROUGH A larger rough drawing is then created from the thumbnail, so that the artist can better consider what form the abstract shapes may take on in the final "realistic" rendering. A few figures included on the right, wading to shore in this violent storm, provide scale and human, emotional dimension to the piece. Dark framing shapes surround the figures and create a horseshoe shape that circles back toward the mass of rock on the left.

3. IMPROVING THE ABSTRACT After rendering the large rough, the artist returns to the abstract to reconsider the new elements introduced by "reality." He grows the focal point of rock mass and reduces the figures further. The sky/horizon line (see p. 38) is brought to the very top, and an overall diagonal design to the rocks and the figures' gestures is clarified as a major compositional device.

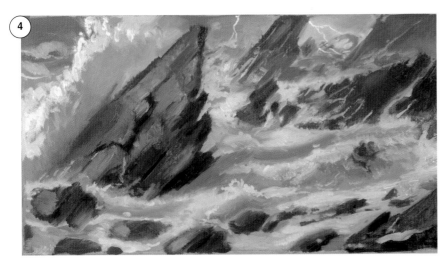

4. COLOR STUDY After acquiring photographic reference for the figures and environments, a color study is created using acrylics and oils. The reference material allows the artist to better understand lighting and color choices that will present this painting as a realistic event. Other references included a book on the sea and shoreline and wave impact images sourced from the Internet.

5. REALISTIC RENDERING The artist renders the final art in oils on a prepared panel ground, closely following the color study and abstract rough for cues on major shapes and movement. The overall color choice has veered away from the aquamarine toward blue and purple, in order to create a night effect. The artist constantly refers back to his photographs for information on values (see p. 30), color, and details, while unprepared changes keep the painting fresh and interesting.

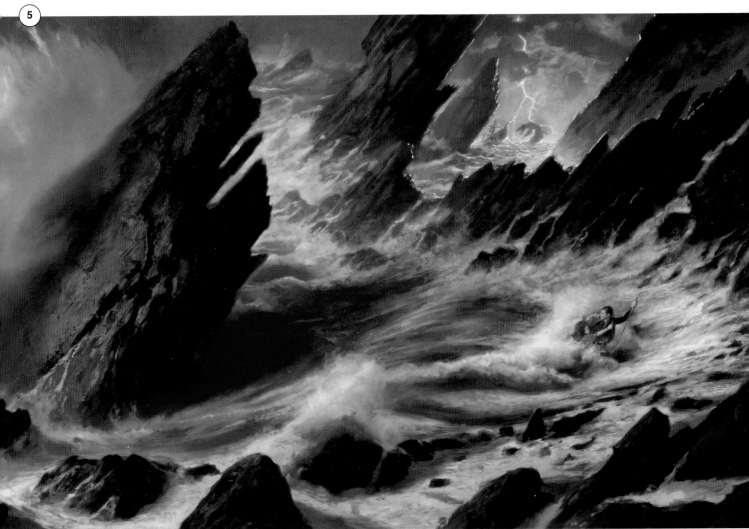

WATER WORLD

Ilene Meyer was inspired to create Return to the Fatherland *when she found Koi fish in many places around the world. The main source for them is Japan and Asia; therefore, in her painting the fish seek the landscape of their home. The artist uses oil paints on gessoed canvas, and the work has many layers and glazes (see p. 15) applied so that the finished product is like silk.*

1. QUICK SKETCH The artist always works quickly when making drafts. The original draft for this work took less than one minute to complete, using felt pens.

2. SHADING The pictures are transferred to the canvas and lines are darkened and shaded with thinned oil color.

(1)

(2)

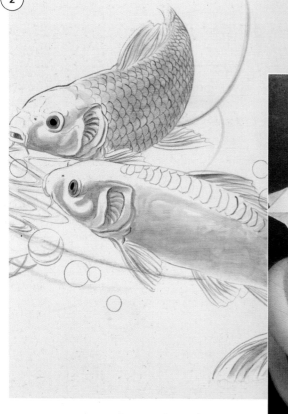

3. TEXTURING The background is painted in, but not so thick that the artist can't see the lines. Some of the foreground and water spray around the globe is textured with a mixture of titanium white oil paint and resin.

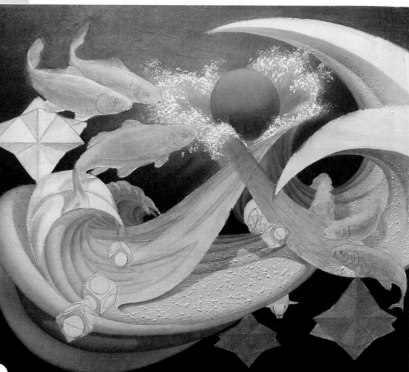

(3)

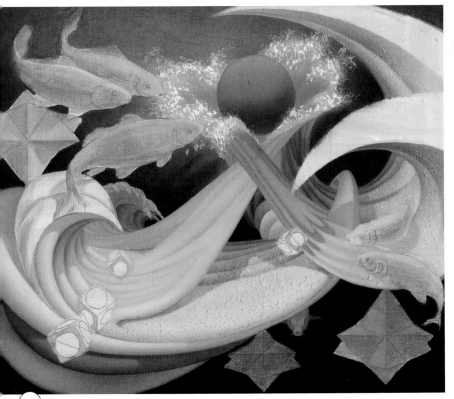

5. CONNECTING THE FOREGROUND The overlapping water is painted with all the continuing areas connecting the foreground. The tendrils are painted with a thicker glaze and very pale check lines added.

6. PAINTING THE CHECKS A thin base is painted on the water spray and the connection of the overlapping yellow-green water is completed. At this stage the artist begins to paint some of the checks on the tendrils.

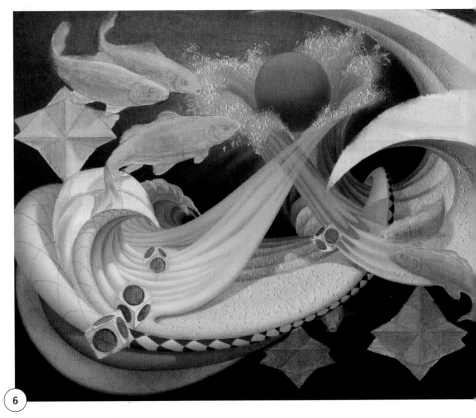

4. GLAZING A glaze of the same colors is painted in various combinations to the dark areas, but not the water spray. Thinned color is painted on the other areas, including the fish and the orbs, just for a base. The tendrils and foreground are painted, but you can still see some of the guidelines on the tendrils.

7

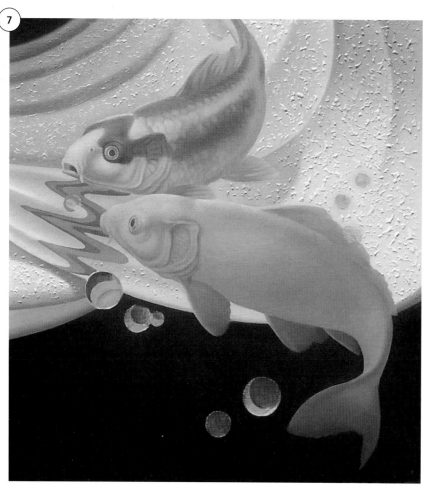

7. THE FISH The artist paints gold swirls in the foreground and applies a thinned oil color to the fish (each layer must be dry before the next can be painted). Also worked on at this stage are the rest of the checks and the swirl, the scales, fins, and water orbs.

8

8. GEOMETRIC STARS After painting an entire star form, including all highlights and glazes, a very fine sharp but smooth dental scraper is used to cut the design into the shapes (see p. 15). You only get one chance at this, so if it goes wrong you need to scrape it all off and start again.

9. FINISHED PIECE The finished piece has many things going on at once, creating visual excitement.

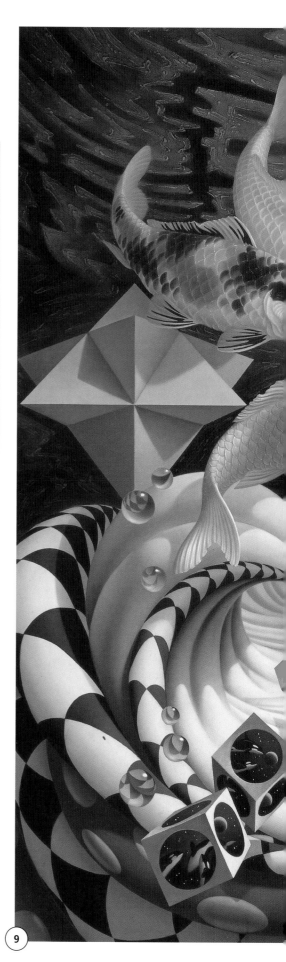

9

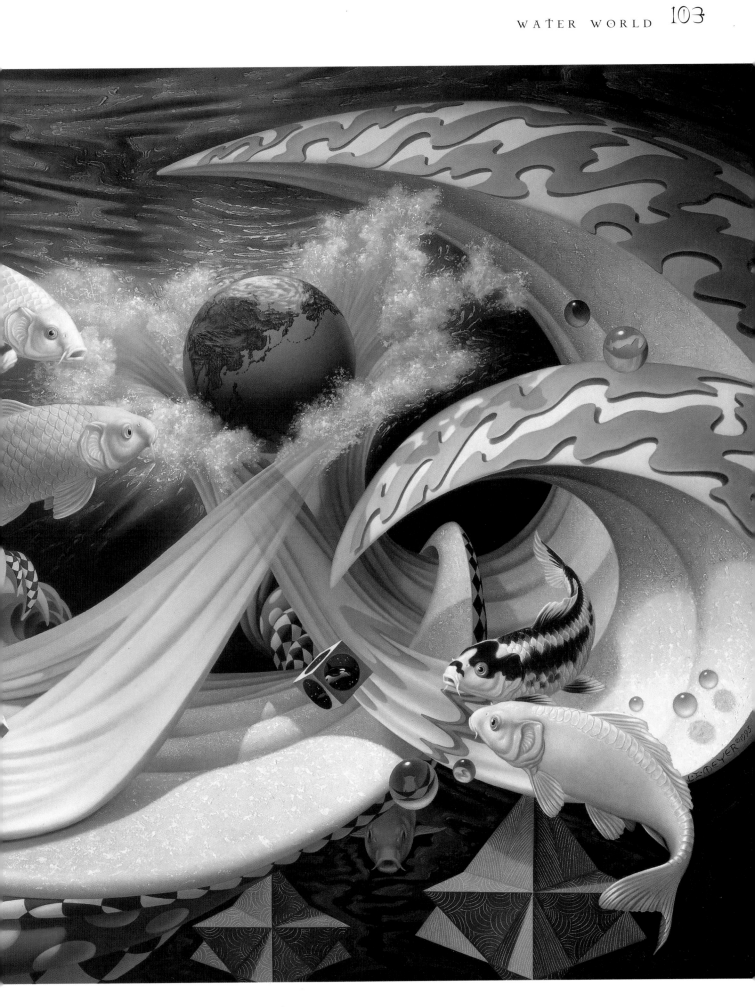

DREAM LANDSCAPE

Bryce is a computer design program that allows artists to create three-dimensional landscapes. The artist has control over terrain, sky, weather, lighting, and viewpoint, so that the image can be viewed from any angle within the program. When creating Dream Friends, *fantasy artist Jurgen Ziewe used Bryce to produce an image with the atmosphere of a dream.*

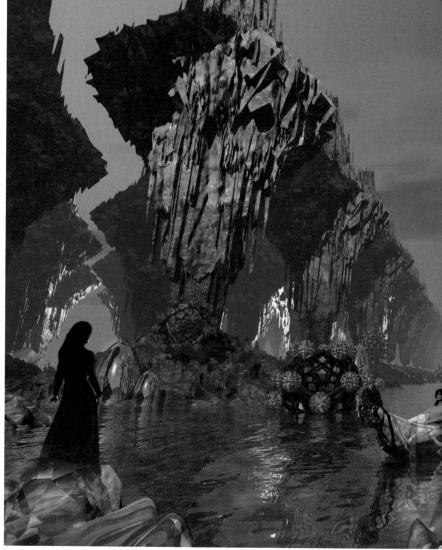

1. TERRAIN CONTOURS When creating a fantasy scene using Bryce, the starting point is often the creation of the terrain. Terrain contours can be created in Photoshop (see p. 16) as a black and white image. This is then used as a displacement map in Bryce. The lighter the areas in the displacement map, the greater the height. Any black and white image can be used for interesting results.

2. EDITING THE TERRAIN The Photoshop image is imported into the Bryce Terrain Editor to create the base terrain. This will form the rather alien top-heavy columns. The ground base of the terrain is clipped off to allow the rock columns to appear separated from one another.

3. COMPOSING THE SCENE In the Quickdraw preview we get a glimpse of the first composition after various objects have been imported from other programs. The strange shapes and gondola were created in Lightwave and imported into Bryce.

4. SURFACE QUALITIES After the imported objects are smoothed, they need to be resurfaced using the Bryce Material Editor. The artist separates the objects in Bryce, and water and mountains all receive their unique surface. Because this is a dream image, realism is not an issue.

5. CHANGING VIEWPOINTS Using the Bryce aerial view of the scene, the artist can introduce light sources and duplicate imported objects to populate the scene. A bird's-eye rendering helps to identify what's going on in the scene.

6. CONTROLLING ATMOSPHERE The main punch of the image is dependant on atmosphere and lighting. In Bryce Skylab everything from the time of day, the size of the sun and moon, haze and mist, ground fog, and stars to the size and movement of the clouds can be created with dramatic effect.

7. THE FIGURE The figure is rendered in Poser, using its powerful lighting environment. The figure is to appear ghostlike and semitransparent; she is composed into the final scene in Photoshop, remembering to be consistent with lighting when working in different programs.

8. BRINGING IT ALL TOGETHER The lady on the left is framed by the mountains. The gondola acts like a spoke on the vanishing points (see p. 38) of the mountains and water. The composition supports the action, empasizing the tension and attraction between the two figures.

AT THE END OF IT ALL

At the End of it All is a painting Rob Alexander was commissioned to make for a short story collection set in the dying days of a great empire. Rather than portray a literal scene from one of the stories, he chose to capture the feeling of the collection as a whole. The artist's work is all about storytelling, and even though there was a body of work from which he drew inspiration, he wanted to create a visual story that encompassed the collection as a whole.

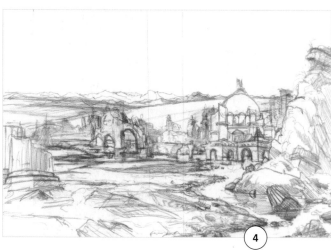

1. THUMBNAILS These thumbnail sketches were an exploration of different architecture, viewpoints, and compositions done in a very quick rough way, allowing the artist to focus on the main elements and to find the heart of the painting, which would provide the unifying force that would tie it all together. This force came about in the main thumbnail sketch (step 2), which gave him the vantage point of the painting and conveyed the feeling that he wanted.

2. THE MAIN THUMBNAIL This sketch was enlarged and fleshed out, and a gutter added to allow for the spine of the book. The architecture was refined considerably, and a sense of the world began to emerge.

3. NEW COMPOSITION The artist continued to churn over ideas for the painting. This led to a very different sketch being produced, and because he felt it conveyed what it needed to more effectively than the earlier sketch, he opted to run with this new composition.

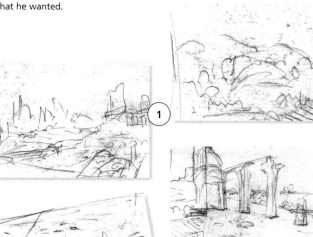

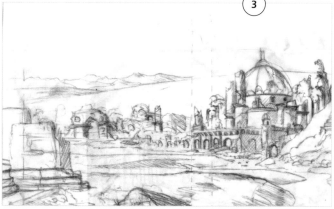

4. REFINING The sketch is refined, a sense of depth and place is established more clearly, the architecture is resolved, and a balance is established between large open areas and busy, detailed sections of architecture.

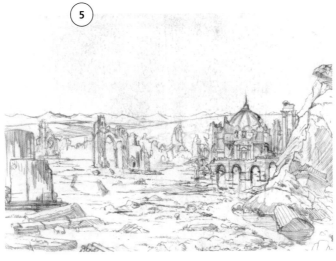

5. FURTHER REFINEMENT The composition has been refined further still. There is a better balance, the main arch in the mid-ground serving as a counterpoint to the dome and pillars on the right. The architectural behind them has been simplified into a unified mass (see p. 29) of buildings. Rubble in the foreground has been resolved, and the water and reflections worked out more precisely. At this point architecture reference was gathered—mainly old Greek and Roman ruins, Turkish and Persian elements, and Gothic cathedrals for the ruined arches. Aspects of all these sources were incorporated into the drawing to add complexity and realism to the design.

6. COLOR STUDY A color composition was done. This allowed the artist to work out the values (see p. 30), basic colors, and temperatures (see p. 34) simultaneously, and begin to note potential trouble spots in the painting, where elements may still compete with each other. The sense of depth was more clearly established, the ruined city pushed back sufficiently to allow the two main elements to read clearly, and the ground plane further simplified in order to unify the foreground.

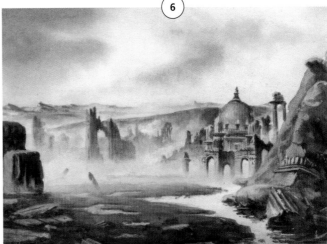

7. THE FINAL PIECE The final drawing was enlarged and transferred to stretched watercolor paper. Beginning with the sky and the background elements, the painting was laid in quickly, using the color study as a guide. A lot of water was used in the initial washes (see p. 11), with paint being applied more and more drily as the painting progressed. Once everything was about 80 percent complete, opaque white was introduced to enhance the atmospheric effects, clean up some of the edges in the architecture, and strengthen some of the main light areas, such as the dome. Chinese white was used with a touch of Naples yellow to mimic the look of the watercolor paper; then transparent watercolor was dry brushed (see p. 11) over the top, creating a glaze (see p. 11) and maintaining the look and luminosity of the watercolor.

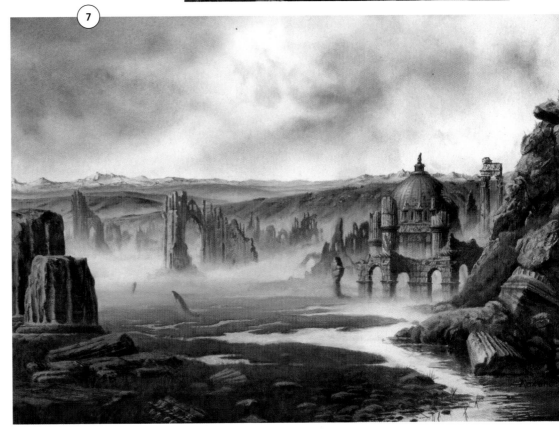

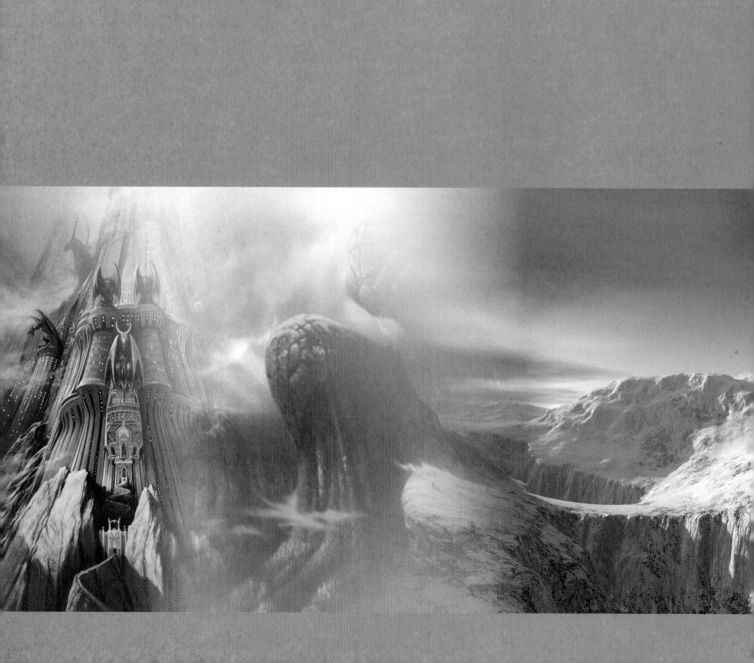

CHAPTER 4

GALLERY

The following pages showcase several artists who know the rules and, more important, when, where, and how to bend, push, and break them. Exploring a wide range of media, styles, and techniques, the Gallery is an inspirational display of images from working artists.

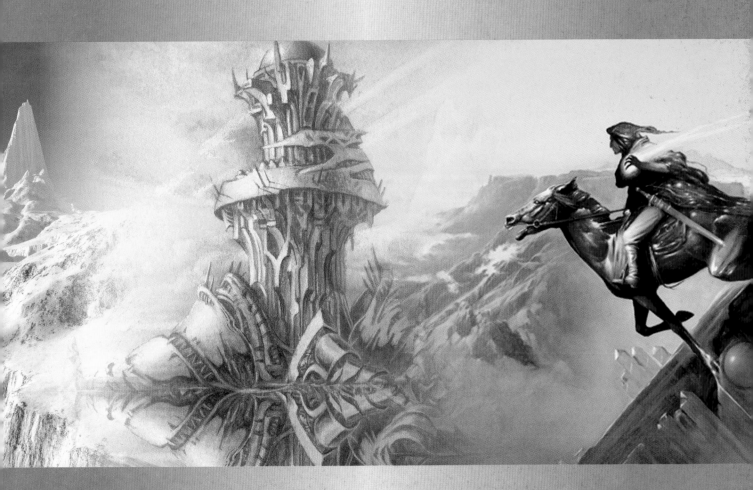

A LAND OF GIANTS

Sweeping fantasy
panoramas can often
include majestic features
that possess an alien
scale—aspects of a
landscape that seem to
display the direct influence
of all-powerful celestial
intervention, features that
could surely have been
sculpted only by the hands
of the Gods themselves. In
these images Christophe
Vacher has created striking
paintings of truly epic
proportions, conveying an
unearthly grandeur.

▶ MOUNT OF THE
IMMORTALS
CHRISTOPHE VACHER,
OILS
Like the figurehead prows of
colossal ships looming from a
Stygian gloom, these vast and
mysterious outcroppings of
stone form a bleak escarpment
which shoulders the stormy sky.
The foreground trees, the skirt of
low cloud, and the microscopic
human figure all illustrate the
truly gargantuan nature of
this landscape.

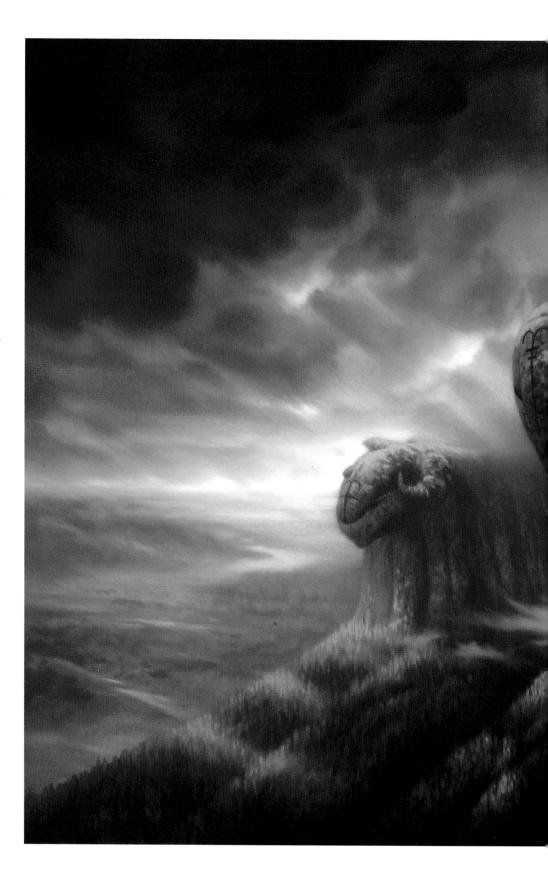

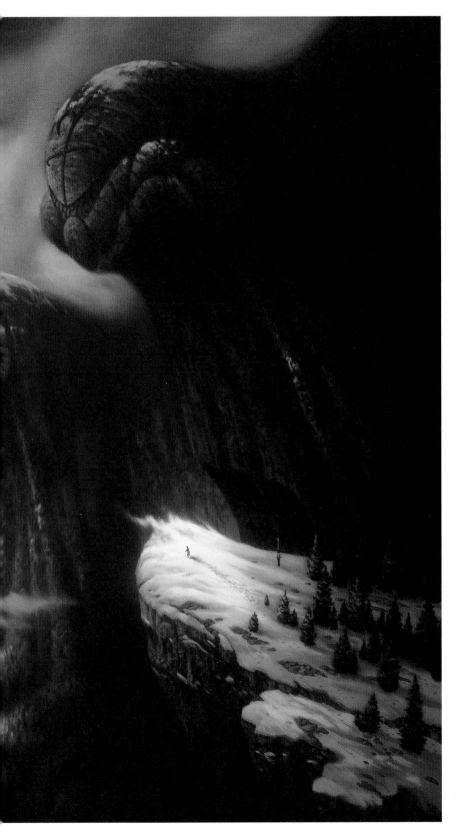

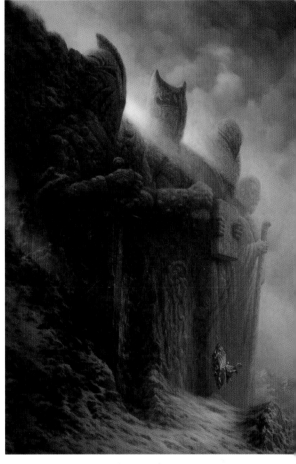

▲ THE GIANTS
CHRISTOPHE VACHER, OILS

These ancient statues, carved from the face of an immense crag of dark rock, appear to portray knights, armored warriors, or perhaps priests. Are these depictions of deities laboriously hewn by human hands, or are they life-size statues created by a race of giants? Their origin and significance are perhaps now long lost. The magical floating island of rock near their feet, and the shafts of light penetrating the heavy cloud high above, serve to drive home the carvings' immense size.

CITIES OF MYSTERY

The labyrinthine tangle of streets and buildings that make up fantasy cities provides a wealth of fascinating views to set the imagination soaring across the rooftops. The figures glimpsed in these cities not only lend scale to the architecture but also immerse the viewer in the painting and draw the viewer to imagine the lives led by the citizens of these strange places. This can be seen with these two intriguing figures found in two quite different fantasy city settings.

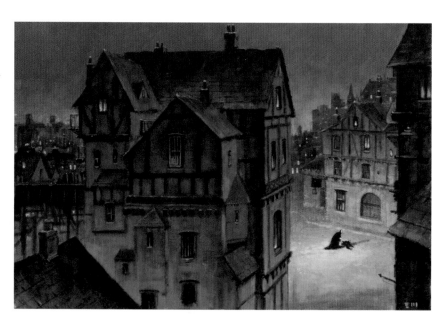

▲ BLOOD FOLLOWS
EDWARD MILLER, ACRYLICS

Warmly spot-lighting the key area of this composition, the artist immediately grabs the viewer's attention with the dark figure and its long shadow thrown across a prone body. The focal point of this scene is an eerie tableau. From afar this cloaked figure, a creature of the night, appears hunched and ill at ease in the street light. The rest of the city appears in a shadowy palette of blues and browns.

◄ CATHEDRAL CITY
RICHARD WRIGHT, DIGITAL

A complex Gothic metropolis, with avenues of mighty cathedral structures marching away into the smoggy haze. Trees strain toward the light, reaching up between flying buttresses and growing from within huge domes. Zeppelin-like flying ships are shown weaving their way through the spires, going in and out of shadow, dwarfed by the towers.

NIGHTLANDS

The uneasy atmosphere and subtle horror conjured in classic ghost stories, such as those crafted masterfully by M.R. James, are among the most difficult dark fantasy subjects to capture visually. In these images the eeriness of sinister figures moving within mysterious nocturnal landscapes invites the viewer to guess at what nightmarish events are unfolding within these shadowy lands of fear.

▲ PHANTOM
EDWARD MILLER, ACRYLICS
In this moonlit scene an unsettling, deathlike figure crouches on a rooftop, pale light glinting upon what might be pallid flesh, or bleached-white bone, glimpsed beneath its flapping black shroud.

The murky green glow of the moonlight recalls the work of Victorian artist John Atkinson Grimshaw, who painted night scenes which often included the smoke, pollution, and damp fogs that were common in industrial cities of Britain in the late 19th century.

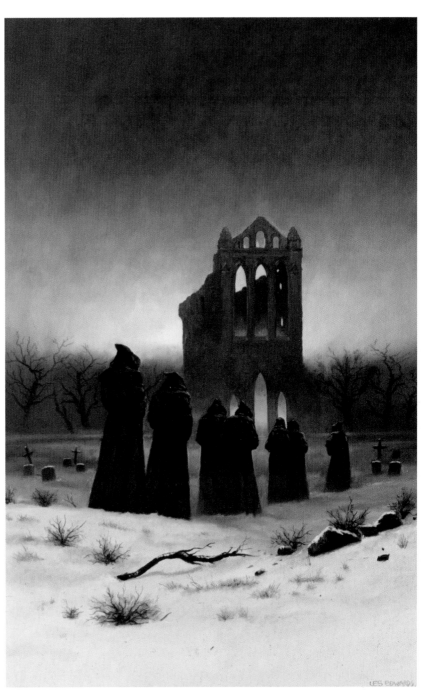

▲ THE LIST OF SEVEN
LES EDWARDS, OILS
A bleak winter landscape featuring a ruined abbey. This work is reminiscent of Abbey in an Oak Forest *by 19th-century German romantic painter Caspar David Friedrich, who was one of the greatest exponents of symbolic landscape painting. Some of his best-known works are expressions of a religious mysticism. As with Friedrich, this image can be appreciated on one level as a bleak winter scene, and on another level as a representation of the church shaken by the Reformation and the transitory nature of earthly things.*

CITY DEPTHS

Overlooked and almost forgotten, dank sewers, catacombs, and old foundations—the dark bowels of a great metropolis—can provide a unique ambience of decayed grandeur or reveal a glimpse of the complex substructure and intricate workings of a high-tech city. The frightening subterranean world of the industrious Morlocks in H.G. Wells' The Time Machine comes to mind, as does the mutant-infested "Under City" beneath Mega City One, in the Judge Dredd series.

▼ UNDERWORLD
RICHARD WRIGHT, DIGITAL

A once grand, sepulchral, Gothic interior is now spoiled, rotting away in murky green depths. A swamp mist clings to the stinking banks of its flooded floor, and the only inhabitants of this shunned place are the birds, circling high between dangling chains, and funereal figures with their torches near the central tower and its viaduct. This crepuscular scene benefits from an excellent composition, which allows us to see intriguing archways and mysterious openings leading away in many directions.

▶ SEWERS
RICHARD WRIGHT, DIGITAL

Swamplike sewers stretch away into the cavernous gloom of this scene. Stalagmites rise like bulging termite mounds from the filthy lagoons, and in both these and the stalactites above, dwellings have been hollowed out to house unseen denizens. Lamps glow in the windows and doorways, and rope bridges are suspended between the dwellings to link this subterranean community together. The palette of sickly yellows and browns and pallid blues really conveys a sense of the fetid air of this place.

▶ THE TOWER
HIDEYOSHI RUWWE, DIGITAL

Looking like moving parts within a vast machine, these jet-pack travelers are dwarfed, speeding along a concave strip of steel toward sizzling electrical components, a vertiginous chasm of technology to one side and reinforced windows spilling light from a coldly over-lit and uninviting interior on the other.

The composition leads the eye into the dark innards at the center of the image, drawing the viewer deeper into its Byzantine hardware and enclosing us within this machine environment.

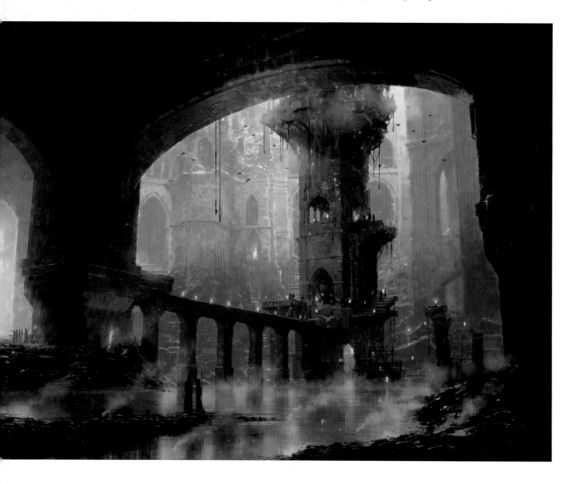

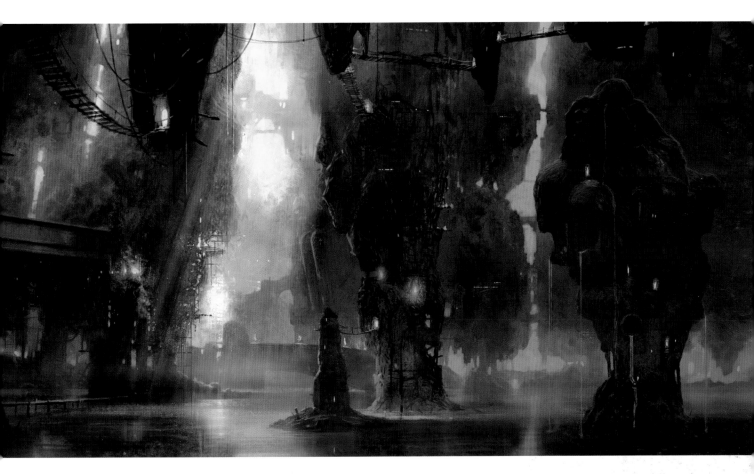

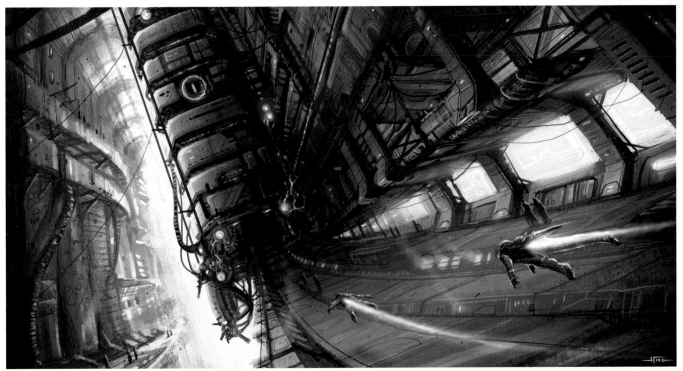

DESERTS OF ICE AND SAND

These bleak expanses of beautiful yet hostile wilderness landscapes range from the most dry, arid desert with its endless seas of dunes and scouring sandstorms to the freezing glacial solitude of the icy hyperborean wastes. The strongly contrasting warm and cool palettes of these images instantly distinguish the nature of their very different yet equally inhospitable environments.

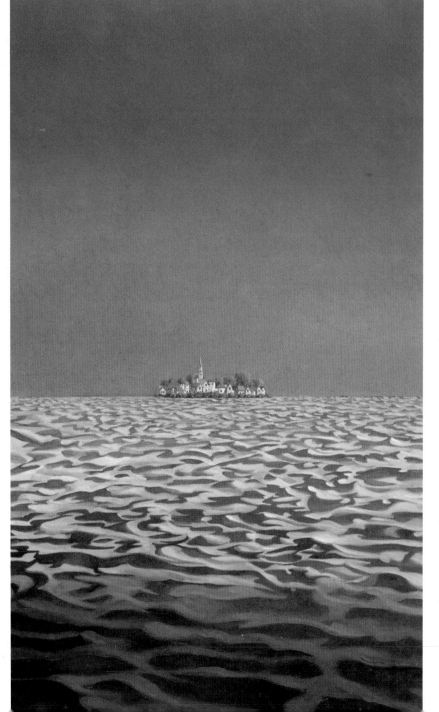

◀ BAGHDAD
BRYN BARNARD, OILS

A warm palette here conjures the parched heat of the desert. A cloudless blue sky meets a plain of stylized sand dunes, at which point on the flat, central line of the distant horizon, at the heart of the picture, we see a strange oasis. This is a desert island, a stand of trees and shrubs sheltering what appears to be an English country village, paradoxically relocated and adrift on this dusty ocean.

▶ RARLONN RANGE ICE PASS
PAUL BOURNE, DIGITAL

The cool palette used in this 3D rendering effectively conveys the bite of frosty arctic air. The finely detailed texturing of the frozen ground, along with the carefully chosen low angle of the crisp winter sunlight casting its precise shadows, is convincingly realistic, almost photographic in its flawless finish. It takes the exaggerated canine-like peak, jutting in the middle distance, to remind us that this desolate realm is one purely of artistic invention.

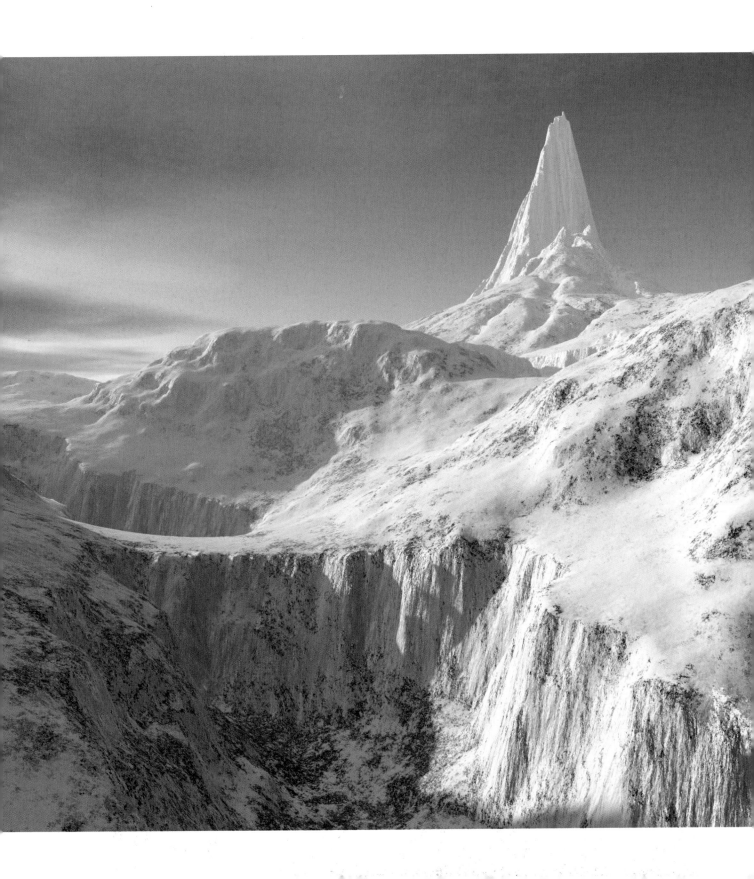

PLANES OF UNREALITY

Bizarre and otherworldly images, strange
in their mystifying and surreal detail, here
are made to leap from deep within the
imagination and into convincing life.
These images offer a glimpse into an artist's
individual mental landscape and bring
into existence places or situations that are
absorbing abstractions of our own reality.
In these scenes curious combinations of
shapes and forms are employed, forcing us
to look more closely and question what it
is we're seeing.

▶ TEN THOUSAND SAILS
BRYN BARNARD, OILS

*The ethereal sweeping curve of these celestial sailing
ships combine, above and below, to create an elegant,
organic, serpentine form, which floats serenely in deep
space carried by astral winds. The single, straight, bold
line of the shadow cast by the span of the deck creates
a pronounced counterpoint to the sensuous organic
curves above it, lending a strong unity to the
composition as a whole.*

◀ DERYNI
MELVYN GRANT, OILS

*This horse and rider are frozen in
mid-gallop, at once leaping from
and part of the angular summit of
a crystalline peak. The organic
forms of the horse's limbs appear to
be rooted in and pulling free from
the sharply contrasting hard-planed
facets. The glassy sheen on the
figures suggests they are trapped like
flies in amber and have perhaps
been magically placed here, the
rider's glowing spell caught forever
in mid-cast.*

VISTAS OF RUINS

As the Victorians understood, there is something wonderfully romantic about ruins. They can be deeply mysterious, withholding the secrets of lost civilizations, and conversely, they can dramatically symbolize the tragic collapse of a society, either ancient or modern. The following images present a contrast between the wanton ruination of a natural landscape through industrialization, and the crumbling remains of a proud civilization slowly being reclaimed by nature.

▼ LAND OF FIRE
RICHARD WRIGHT, DIGITAL

A hellish vision of industry gone mad, a sprawling smelting works having ravaged the landscape to smoulder within it and surge and boil from every crevice of the ruined earth. Swathes of the land have collapsed into the furnace, to leave teetering promontories linked by metaled roadways, while fingers of stone have become smoking factory chimney stacks bellowing forth noxious fumes, networks of pipes running between them. This infernal spectacle is burning in the apocalyptic red glare of a dying sun.

▶ PARLAINTH
LES EDWARDS, OILS

A formal composition bringing us, like intrepid explorers, into the heart of a fallen ancient metropolis. The vanishing point leads the eye neatly over the subterranean catacombs to the base of the distant pyramids and finally upward to fully appreciate their monumental scale. The architecture and statuary intriguingly, and successfully, mixes aspects of Aztec, Egyptian, and Roman designs into an ultimate lost empire.

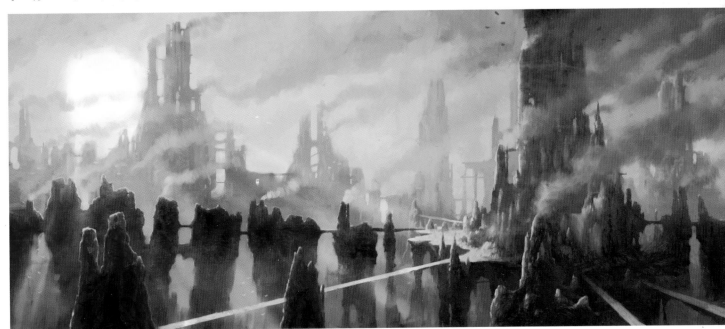

STRANGELY FAMILIAR

Famous landmarks and familiar buildings can be used very effectively to convey powerful science fiction and fantasy ideas when placed in a surprising or unfamiliar context. They can be used to impart warnings and provide glimpses of shocking futures. A memorable example of such striking and iconic imagery is the revelation of a ruined Statue of Liberty, found buried on the beach at the climax of Planet of the Apes.

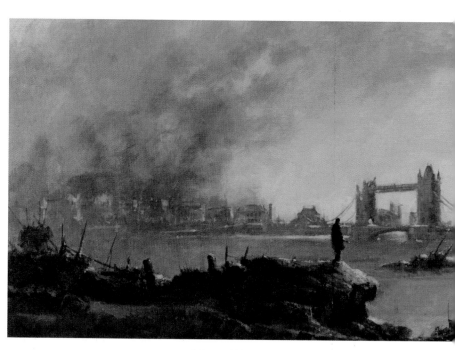

▲ THE TAIN
EDWARD MILLER, ACRYLICS
A solitary figure stands forlorn amid the apocalyptic ruins of a devastated London. The familiar towers and walkways of Tower Bridge, now a broken wreck, are silhouetted against a reddened sky that suggests fires are still burning across the city. The imagination races to consider what might have caused such widespread destruction.

◀ VENICE ON THE POTOMAC
BRYN BARNARD, OILS
A flooded U.S. Congress, accessible now only by gondolas, which compliment its Italianate architecture and transform it into an incongruously classical Venetian scene. This is an incongruous vision of Congress, brought about by rising sea levels, caused by global warming and the melting of the polar ice caps, the result of our wasteful industrial lifestyle—perhaps now even more easily imaginable, after the disastrous flooding of New Orleans in 2005.

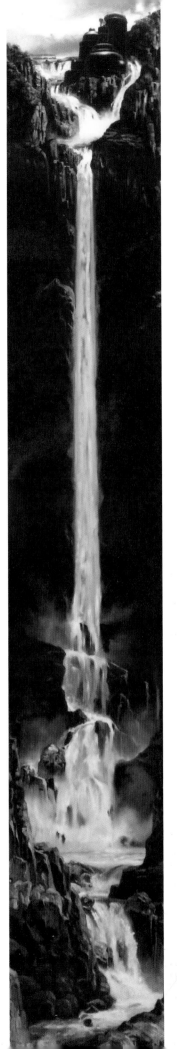

WATERY DOMAINS

From epic depictions of ferocious ocean squalls to visions of listless lakes gleaming like tarnished silver under darkening heavens, water can be used to great effect in scenes of fantasy. The harbors and docks of bustling fantasy ports, the mighty rivers and majestic waterfalls of magical kingdoms, are all strong and interesting subjects that can make for instantly engaging landscape features.

◄ THE OBSERVATORY AT ALBIREO
BRYN BARNARD, OILS

The observatory is shown as a complex of dark buildings set in the middle of a river at the brink of a high waterfall. Bryn Barnard has chosen to use this distinctive, tall, vertical composition in homage to a famous Japanese painting of the Kamakura period, the Nachi Waterfall, *a late 13th-century image based on the concept of suijaku, the unity of Shinto and Buddhism. This arresting canvas shape also emphasizes the spectacular height of the waterfall itself, following the elegant line of the water as it cascades downward.'*

▼ BUCCANEER
MELVYN GRANT, OILS

This wild seascape perfectly captures all the spirit of adventure of the High Seas and tales of Caribbean pirates. The dark storm clouds are twisted in agonized tangles of muscular forms and ragged veils across the shredding sky, whipping the sea into a whitecap-flecked frenzy. You can almost smell the cold, briny sea from the vantage point on the jagged rocks, where it's likely the galleon may soon run aground.

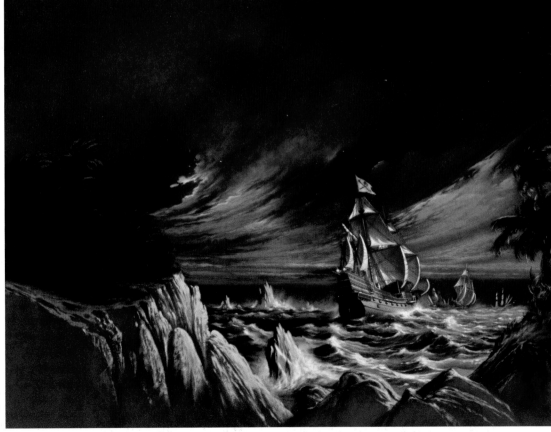

TOWERING FANTASY

Fortresses, castles, and towers, in all their metaphoric implication, have forever been central to fantasy: everything from King Arthur's Camelot, to Castle Dracula, Kafka's The Castle, *and Mervyn Peake's astonishing creation* Gormenghast, *as well as countless others. In the following images, vertiginous skyscrapers of fantasy are depicted in various media and from different and carefully chosen viewpoints.*

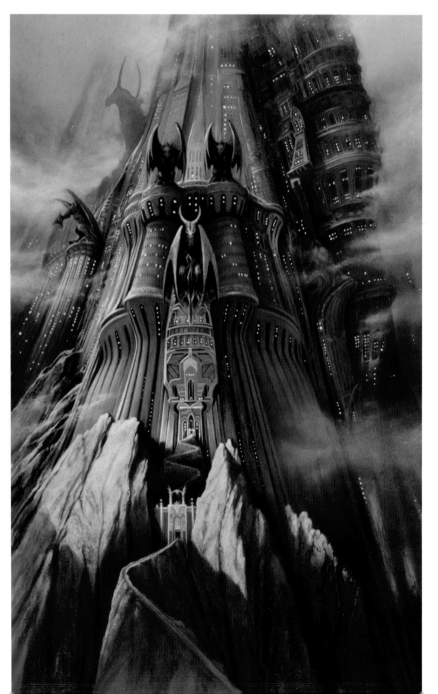

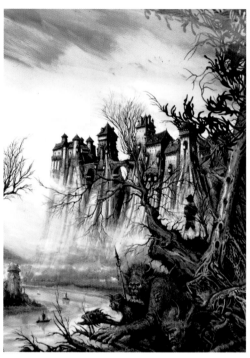

▲ INNSMOUTH HILL
IAN MILLER, ACRYLICS AND GOUACHE
Rising almost ghostly from the mist, Ian Miller's towering castle broods, indomitable and imposing over the river and the lands beyond. A wonderful balance of shapes, values, and colors in the fore-and mid-ground allows the eye to travel from the castle to the shadowy creatures and back again, while the ships on the river give us a sense of scale and unify the entire composition.

◀ THE HOUSE
MELVYN GRANT, OILS
A vast, sprawling mountain fortress, a menacing vision of the ultimate Gothic fantasy pile. Melvyn Grant has chosen a low point-of-view here, to emphasize the unknowable height and impossible scale of this monstrous building, and to instill a dominating and intimidating presence, making it loom at the viewer in an imposing manner.

▶ KURNOR IMPERIAL AND WATCHTOWER
PAUL BOURNE, DIGITAL
These forbidding edifices convey a palpable sense of oppressiveness, recalling the dark watchtowers and fortresses of Mordor in Tolkien's The Lord of The Rings. *Paul Bourne has used 3D software to create very precise and well-textured architectural details, producing structures that feel very solid and real. Atmosphere is conjured using heavily overcast skies, with low clouds billowing across the lower reaches of the towers, giving a tremendous sense of their lofty elevation.*

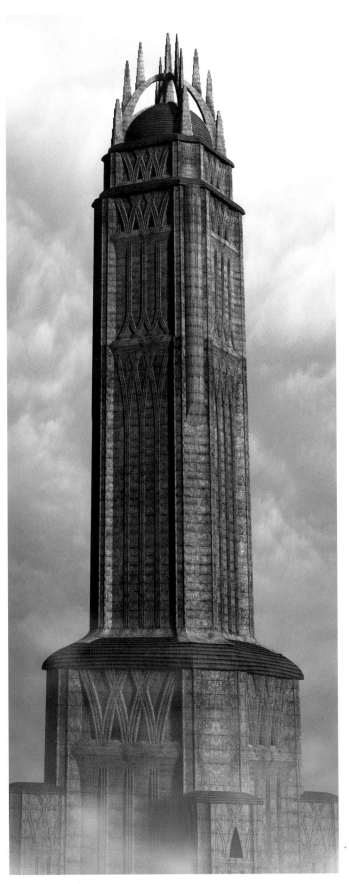

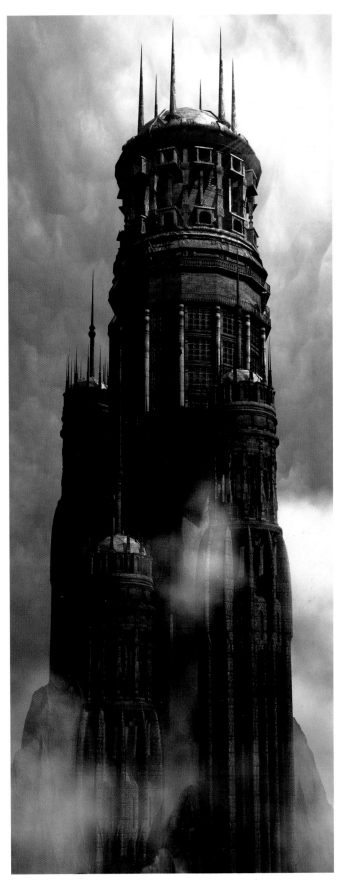

FANTASTIC VIEWPOINTS

The fantasy artist can pick and choose a viewpoint for his or her image, whether it be a high, distant vantage point or up close and personal. For the landscape artist, the world is not a backdrop for the real story, it is the story. The landforms, the architecture, the lighting, and the weather—all the elements that make up the world are the central characters in a landscape painting, and the artist must decide what aspects of these characters to represent, and how.

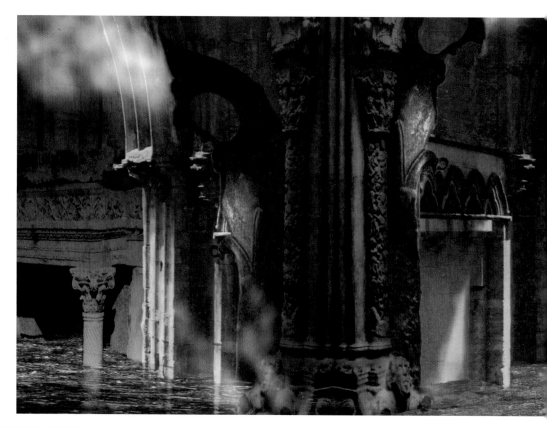

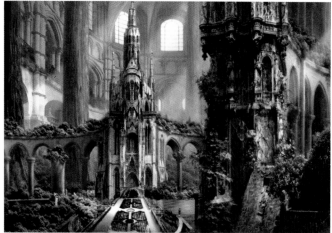

▲ THE TEMPLE GARDEN
ROB ALEXANDER, MIXED MEDIA

An elevated vantage point was chosen to capture the grandeur and epic scope of the image. While the foreground forms on the right provide detail and create a sense of scale, the main thrust of the image is the beauty and the immensity of the cathedral within a cathedral. To convey all this in a single glance requires a high, distant viewpoint, as if the viewer were standing on a balcony several stories up, looking out over the scene.

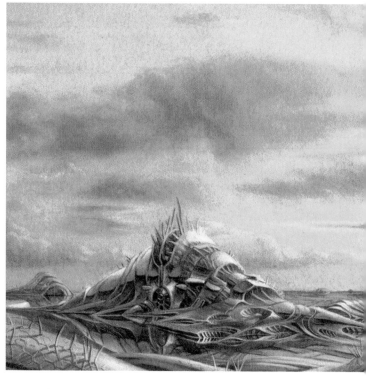

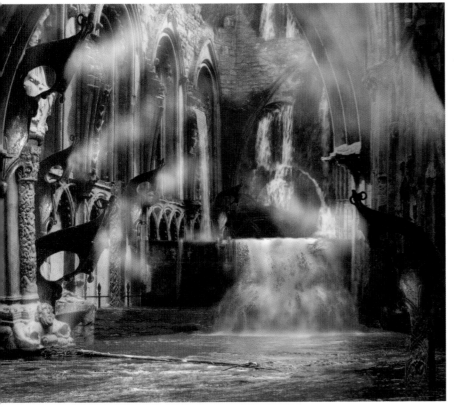

◄ AMONG THE RUINS
ROB ALEXANDER, DIGITAL

The scene is viewed from a height that is roughly that of a standing person. This combined with the close-cropping wide angle and the open composition all work together to place the viewer directly into the scene, as if he or she is wandering through the ruins. This gives the ruins a personality, a history, and it instantly creates a story about them—a story into which the viewer is drawn, engaging the viewer's imagination and making the image that much more real.

▼ THE GREAT RAZOR PLAINS
ROB ALEXANDER, WATERCOLOR

This image establishes the world it portrays as a single character. This is achieved by using a distant vantage point with a panoramic composition, establishing the structures and elements of the scene as a unified whole before the viewer becomes aware of individual elements. The vantage point does not draw the viewer intimately into the scene, but instead serves to convey quickly and clearly that this is an alien world.

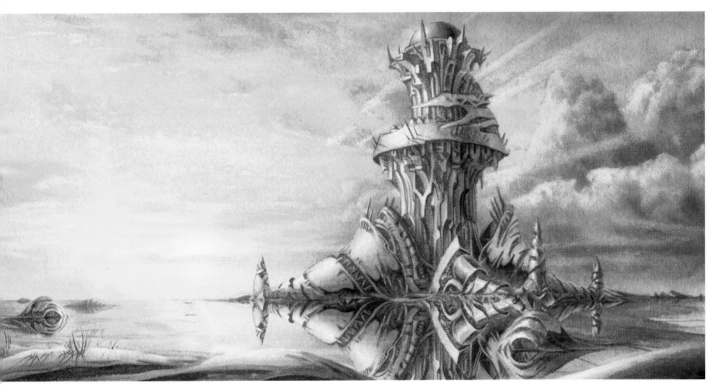

INDEX

Quarto would like to thank and acknowledge
the following for supplying illustrations
reproduced in this book:

Key: t = top, b = bottom, l = left, r = right, c = center

Rob Alexander (www.robalexander.com): 19, 20, 21t, 21c, 22b, 23, 25bl, 25bc, 25br, 26, 27, 28, 29, 30, 31b, 32, 33bl, 34b, 35, 37, 38b, 39b, 40, 41t, 42, 43t, 43cl, 43cr, 44–45c (except 45cl), 45br, 46, 48–49cb, 51t, 53cr, 53bl, 54, 55t, 55c, 58, 59t, 59br, 60, 61t, 61cr, 61b, 62, 63tl, 63b, 64, 65tr, 65b, 66, 67, 86–89, 106–107, 124–125.

John Avon (www.johnavon.com): 61cl, 90–91. Used with permission © 2006 Wizards of the Coast, Inc. (www.wizards.com).

Bryn Barnard (www.brynbarnard.com): 45cl, 116, 118t, 120b, 121l.

Paul Bourne (www.contestedground.co.uk): 117, 123. Used with permission © 2006 Spartans Unleashed (www.cursedempire.com).

Alan M. Clark (www.alanmclark.com): 84–85.

Les Edwards (www.lesedwards.com): 113r, 119t.

Donato Giancola (www.donatoart.com): 98–99.

Melvyn Grant (www.melgrant.com): 118b, 121r, 122l.

James Hogkins: 9, 11, 13, 15.

Tom Kidd (www.spellcaster.com): 70–75.

Ilene Meyer (www.ilenemeyer.com): 92–95, 100–103.

Edward Miller (www.edwardmiller.co.uk): 112t, 113l, 120t.

Ian Miller (www.ianmiller.org): 122r.

Hideyoshi Ruwwe (www.hideyoshi-ruwwe.com): 115b.

Francis Tsai (www.teamgt.com): 44cl, 44cr, 44b.

Christophe Vacher (www.vacher.com): 96–97, 110, 111.

Anthony Waters (www.thinktankstudios.com): 24t, 76–83. Used with permission © 2006 Wizards of the Coast, Inc. (www.wizards.com).

Richard Wright/ARK (www.arkvfx.net): 43b, 112b, 114, 115t, 119b. Used with permission © 2006 Wizards of the Coast, Inc. (www.wizards.com).

Jurgen Ziewe (www.lightandmagic.co.uk): 104–105.

These images by Rob Alexander are used with copyright permission granted by the following:

© 2006 Wizards of the Coast, Inc. (www.wizards.com): 18, 24b, 25t, 25cr, 25cl, 31c, 32tr, 36t, 36br, 39tl, 47, 48tl, 48tr, 50, 52, 53br, 55b, 63tr, 65tl, 86–89, 124l, 124–125b.

© 2006 Tolkien Enterprises (www.tolkien-ent.com): 49tr, 49br, 51b, 53tl, 59bl.

We are also indebted to Alan McKenzie for his work on pages 16–17.

All other illustrations and photographs are the copyright of Quarto Publishing plc. While every effort has been made to credit contributors, Quarto would like to apologize should there have been any omissions or errors—and would be pleased to make the appropriate correction for future editions of the book.

Dedication

This is for Nick, with special thanks to Mom and
Dad, Robert B., Bill P., Dean W., and Geoff L.
who have all helped enormously in their own ways.

R.A.